W9-CDX-017

PAINT ALONG WITH **JERRY YARNELL** • VOLUME TWO

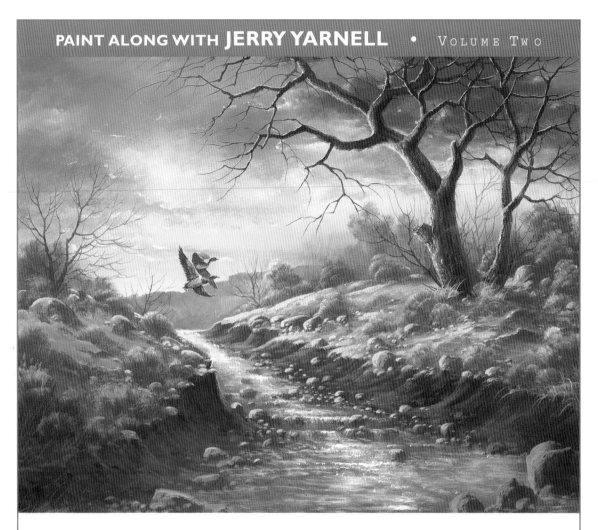

PAINTING

Inspirations

NORTH
LIGHT
BOOKS

CINCINNATI, OHIO
www.nlbooks.com

ABOUT THE AUTHOR Jerry Yarnell was born in Tulsa, Oklahoma, in 1953. A recipient of two scholarships from the Philbrook Art Center in Tulsa, Jerry has always had a great passion for nature and has made it a major thematic focus in his painting. He has been rewarded for his dedication with numerous awards, art shows and gallery exhibits across the country. His awards include the prestigious Easel Award from the Governor's Classic Western Art Show in Albuquerque, New Mexico, acceptance in the top 100 artists represented in the national Art for the Parks Competition, an exhibition of work in the Leigh Yawkey Woodson Birds in Art Show and participation in a premier showing of work by Oil Painters of America at the Prince Gallery in Chicago, Illinois.

Jerry has another unique talent that makes him stand out from the ordinary: He has an intense desire to share his painting ability with others. For years he has taught successful painting workshops and seminars for hundreds of people. Jerry's love for teaching also keeps him very busy offering workshops and private lessons in his new Yarnell School of Fine Art. Jerry is the author of three books on painting instruction, and his unique style can be viewed on his popular PBS television series, *Jerry Yarnell School of Fine Art,* airing worldwide.

Other fine North Light Books are available from your local bookstore, art supply store or direct from the publisher.

05 04 03 02 01 5 4 3 2 1

Library of Congress Cataloging-in-Publication Data

Yarnell, Jerry.
 Paint along with Jerry Yarnell.
 p. cm.
 Includes index.
 Contents: v. 2 Painting inspirations.
 ISBN 1-58180-100-9 (pbk. :alk. paper)
 1. Acrylic painting—Technique. 2. Landscape painting—Technique. I. Title

 ND1535 .Y37 2001
 751.4'26—dc21 00-033944
 CIP

Editor: Maggie Moschell
Designer: Angela Wilcox
Cover Designer: Brian Roeth
Production coordinator: Emily Gross
Production artist: Kathy Gardner
Photographers: Scott Yarnell and Christine Polomsky

DEDICATION

It was not difficult to know to whom to dedicate this book. I give God all the praise and glory for my success. He blessed me with the gift of painting and the ability to share this gift with people around the world. He has blessed me with a new life after a very close brush with death. I am here today and able to share all of this with each of you because we have a kind, loving and gracious God. Thank you God for all you have done.

Also to my wonderful wife, Joan, who has sacrificed and patiently endured the hardships of an artist's life. I know she must love me or she would not still be with me. I love you, sweetheart, and thank you. Lastly, to my two sons, Justin and Joshua: You both are a true joy in my life.

ACKNOWLEDGMENTS

So many people deserve recognition. First I want to thank the thousands of students and viewers of my television show for their faithful support over the years. Their numerous requests for instructional materials are really what initiated the process of producing these books. I want to acknowledge my wonderful staff, Diane, Scott and my mother and father for their hard work and dedication. In addition, I want to recognize the North Light staff for their belief in my abilities.

FOR MORE INFORMATION

about the Yarnell Studio & School of Fine Art and to order books, instructional videos and painting supplies contact:

Yarnell Studio & School of Fine Art
P.O. Box 808
Skiatook, OK 74070

Phone: 1-(877) 492-7635

Fax: 1-(918) 396-2846

gallery@yarnellart.com

www.Yarnellart.com

Table of Contents

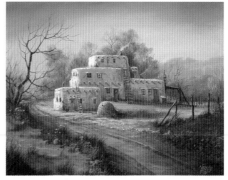

Adobe Village

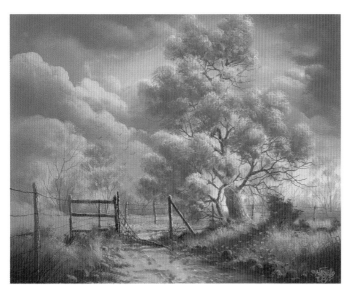

After the Rain

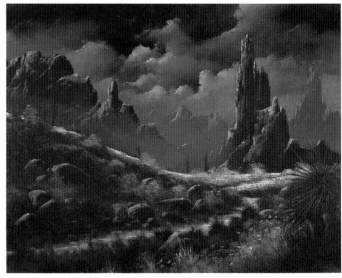

Desert Surprise

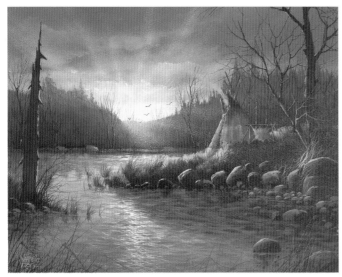

Sunset Camp

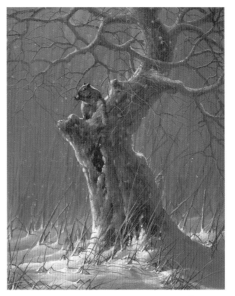

The Nutcracker

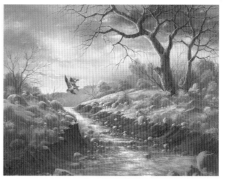

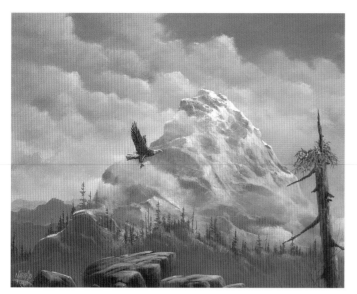

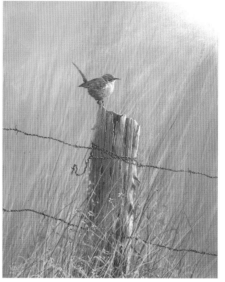

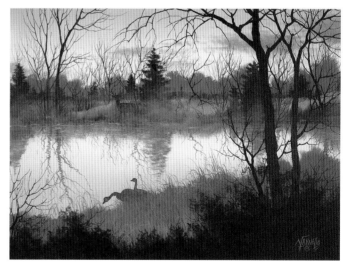

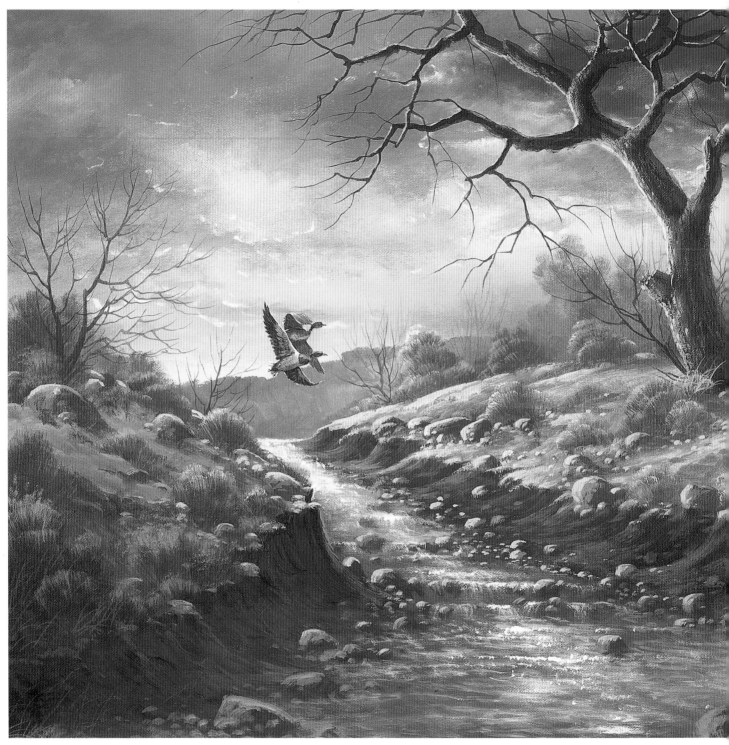

Sunset Mallards
16" × 20" (40.6cm × 50.8cm)

Introduction

Acrylic Painting Volume 2: Intermediate Level 1

I hope that by now you have had the opportunity to complete all the paintings in the beginner book, Paint Along with Jerry Yarnell: Painting Basics. *The beginner book was designed to familiarize you with the techniques I use, as well as build your confidence with brush control, color mixing, values, composition and other basic techniques. In this book do not let the word* intermediate *intimidate you. The reason most people do not grow as artists is that they are fearful to branch out and try new and more difficult subjects and techniques. My whole purpose as a professional instructor is to do just that—to challenge your artistic abilities and give you the necessary instructions and inspiration to try new things. This book will help you do all of that and more. You will learn new techniques, such as how to create different atmospheric conditions including rain, mist, fog, haze, smoke and snow. The paintings in this book will not only challenge you, but will teach you how to use your own artistic license to create these and other paintings. You will learn to personalize your painting to your own unique artistic style. Grab your paints and brushes and let's get started.*

Terms & Techniques

Before beginning the step-by-step instructions on the following pages, you may want to refresh your memory by reviewing these painting terms, techniques and procedures.

COLOR COMPLEMENTS

Complementary colors are always opposite each other on the color wheel. Complements are used to create color balance in your paintings. It takes practice to understand the use of complements, but a good rule of thumb is to remember that whatever predominant color you have in your painting, use its complement or a form of its complement to highlight, accent or gray that color.

For example, if your painting has a lot of green in it, the complement of green is red or a form of red such as orange, red-orange or yellow-orange. If you have a lot of blue in your painting, the complement to blue is orange or a form of orange such as yellow-orange or red-orange. The complement of yellow is purple or a form of purple. Keep a color wheel handy until you have memorized the color complements.

DABBING

This technique is used to create leaves, ground cover, flowers, etc. Take a bristle brush and dab it on your table or palette to spread out the ends of the bristles like a fan. Then load the brush with an appropriate color and gently dab on that color to create the desired effect. (See above example.)

DOUBLE LOAD OR TRIPLE LOAD

This is a procedure in which you put each of two or more colors on different parts of your brush. You mix these colors on the canvas instead of

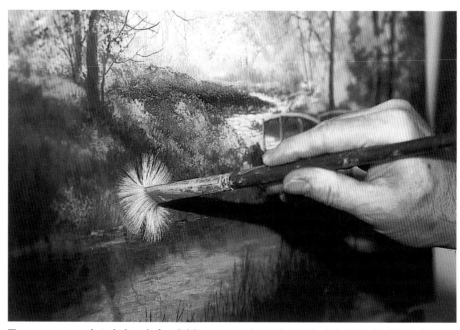

To prepare your bristle brush for dabbing, spread out the end of the bristles like a fan.

on your palette. This is used for wet-on-wet techniques, such as sky or water.

DRYBRUSH

This technique involves loading your brush with very little paint and lightly skimming the surface of the canvas to add color, blend colors or soften a color. Use a very light touch for this technique.

EYE FLOW

This is the movement of the viewer's eye through the arrangement of objects on your canvas or the use of negative space around or within an object. Your eye must move or flow smoothly throughout your painting or around an object. You do not

want your eyes to bounce or jump from place to place. When you have a good understanding of the basic components of composition (design, negative space, "eye stoppers," overlap, etc.), your paintings will naturally have good eye flow.

FEATHERING

Feathering is a technique for blending to create very soft edges. You achieve this effect by using a very light touch and barely skimming the surface of the canvas with your brush. This is the technique to use for highlighting and glazing.

GESSO

Gesso is a white paint used for sealing the canvas before painting on it.

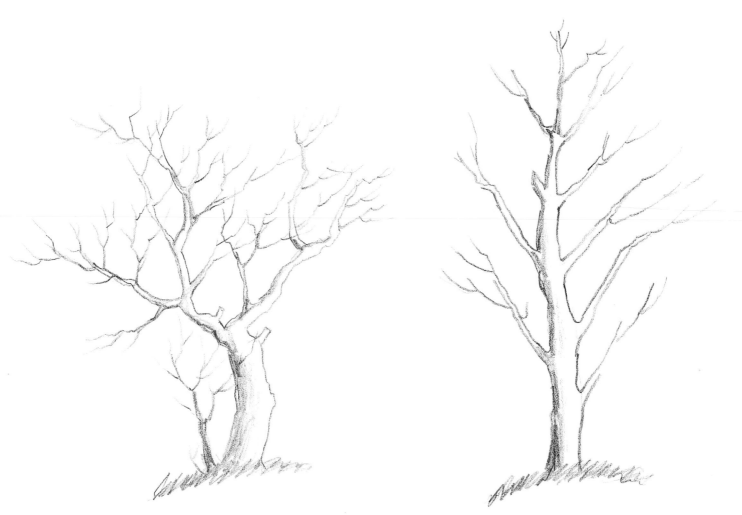

This is an example of good use of negative space. Notice the overlap of the limbs and the interesting pockets of space around each limb.

This is an example of poor use of negative space. Notice the limbs do not overlap but are evenly spaced instead. There are few pockets of interesting space.

However, because of its creamy consistency, I often use it instead of white paint; it blends so easily. I often refer to using gesso when mixing colors. Keep in mind that when I use the word *gesso* I am referring to the color white. If you don't use gesso for white, use Titanium White paint. Titanium White is the standard white that is on the supply list. Please feel free to use it if you prefer.

GLAZE (WASH)

A glaze or a wash is a very thin layer of paint applied on top of a dry area of the painting to create mist, fog, haze, sun rays or to soften an area that is too bright. This mixture is made up of a small amount of color diluted with water. It may be applied in layers to achieve the desired effect. Each layer must be dry before applying the next.

HIGHLIGHTING OR ACCENTING

Highlighting is one of the final stages of your painting. Use pure color or brighter values of colors to give your painting its final glow. Highlights are carefully applied on the sunlit edges of the most prominent objects in the painting.

MIXING

While this is fairly self-explanatory, there are a couple of ways to mix. First, if there is a color that will be used often, it is a good idea to pre-mix a quantity of that color to have it handy. I usually mix colors of paint with my brush, but sometimes a palette knife works better. You can be your own judge.

I also mix colors on the canvas. For instance, when I am underpainting grass, I may put two or three colors on the canvas and scumble them together to create a mottled background of different colors. Mixing color on the canvas also works well when painting skies. (Note: When working with acrylics, always try to mix your paint to a creamy consistency that can be blended easily.)

NEGATIVE SPACE

This is the area of space surrounding an object that defines its form. (See examples on page 9.)

SCRUBBING

Scrubbing is similar to scumbling, except the strokes are more uniform in horizontal or vertical patterns. You can use drybrush or wet-on-wet techniques with this procedure. I use it mostly for underpainting or blocking in an area.

SCUMBLING

For this technique, use a series of unorganized, overlapping strokes in different directions to create effects such as clumps of foliage, clouds, hair, grasses, etc. The direction of the stroke is not important.

UNDERPAINTING OR BLOCKING IN

These two terms mean the same thing. The first step in all paintings is to block in or underpaint the darker values of the entire painting. Then you begin applying the next values of color to create the form of each object.

VALUE

Value is the relative lightness or darkness of a color. To achieve depth or distance, use lighter values in the background and darker values as you come closer to the foreground. Raise the value of a color by adding white. (See example at right.) To lower the value of a color, add black, brown or the color's complement.

WET-ON-DRY

This is the technique I use most often in acrylic painting. After the background color is dry, apply the topcoat over it by using one of the blending techniques: drybrushing, scumbling or glazing.

WET-ON-WET

In this painting technique the colors are blended together while the first application of paint is still wet. I use the large hake (pronounced ha KAY) brush to blend large areas of wet-on-wet color, such as skies and water.

You can raise the value of a color by adding white.

Getting Started

Acrylic Paint

The most common criticism about acrylics is that they dry too fast. Acrylics do dry very quickly through evaporation. To solve this problem I use a wet palette system, which is explained later in this chapter. I also use very specific drybrush blending techniques to make blending very easy. If you follow the techniques I use in this book, with a little practice you can overcome any of the drying problems acrylics seem to pose.

Speaking as a professional artist, I think acrylics are ideally suited for exhibiting and shipping. An acrylic painting can actually be framed and ready to ship thirty minutes after it is finished. You can apply varnish over acrylic paint or leave it unvarnished because the paint is self-sealing. Acrylics are also very versatile because the paint can be applied thick or creamy to resemble oil paint, or thinned with water for watercolor techniques. The best news of all is that acrylics are nontoxic, have very little odor and few people have allergic reactions to them.

USING A LIMITED PALETTE

As you will discover in this book, I work from a limited palette. Whether it is for my professional pieces or for instructional purposes, I have learned that a limited palette of the proper colors can be the most effective tool for painting. This palette works well for two main reasons: First, it teaches you to mix a wide range of shades and values of color, which every artist must be able to do; second, a limited palette eliminates the need to purchase dozens of different colors. As we know, paint is becoming very expensive.

So, with a few basic colors and a little knowledge of color theory you can paint anything you desire. This particular palette is very versatile, and with a basic understanding of the color wheel, the complementary color system and values, you can mix thousands of colors for every type of painting.

For example, you can mix Thalo Yellow-Green, Alizarin Crimson and a touch of white to create a beautiful basic flesh tone. These same three colors can be used in combination with other colors to create earth tones for landscape paintings. You can make black by mixing Ultramarine Blue with equal amounts of Dioxazine Purple and Burnt Sienna or Burnt Umber. The list goes on and on, and you will see that the sky is truly the limit.

Most paint companies make three grades of paints: economy, student and professional. The professional grades are more expensive but much more effective to work with. The main idea is to buy what you can afford and have fun. (Note: If you can't find a particular item, I carry a complete line of professional- and student-grade paints and brushes. Check page 3 for resource information.)

MATERIALS LIST

Palette

White Gesso
Paints (*Grumbacher, Liquitex or Winsor & Newton: color names may vary.*)

- Alizarin Crimson
- Burnt Sienna
- Burnt Umber
- Cadmium Orange
- Cadmium Red Light
- Cadmium Yellow Light
- Dioxazine Purple
- Hooker's Green Hue
- Thalo (Phthalo) Yellow-Green
- Titanium White
- Ultramarine Blue

Brushes

2-inch (51mm) hake brush

no. 10 bristle brush

no. 6 bristle brush

no. 4 flat sable brush

no. 4 round sable brush

no. 4 script liner brush

Miscellaneous Items

Sta-Wet palette

water can

soft vine charcoal

16" x 20" (40.6cm x 50.8cm) stretched canvas

paper towel

palette knife

spray bottle

easel

Brushes

My selection of a limited number of specific brushes was chosen for the same reasons as the limited palette: versatility and economics.

2-INCH (51MM) HAKE BRUSH

The hake (pronounced ha KAY) brush is a large brush used for blending. It is primarily used in wet-on-wet techniques for painting skies and large bodies of water. It is often used for glazing as well.

NO. 10 BRISTLE BRUSH

This brush is used for underpainting large areas—mountains, rocks, ground or grass—as well as for dabbing on tree leaves and other foliage. This brush also works great for scumbling and scrubbing techniques. The stiff bristles are very durable so you can be fairly rough on them.

NO. 6 BRISTLE BRUSH

A cousin to the no. 10 bristle brush, this brush is used for many of the same techniques and procedures. The no. 6 bristle brush is more versatile because you can use it for smaller areas, intermediate details, highlights and some details on larger objects. The no. 6 and no. 10 bristle brushes are the brushes you will use most often.

NO. 4 FLAT SABLE BRUSH

Sable brushes are used for more refined blending, detailing and highlighting techniques. They work great for final details and are a must for painting people and detailing birds or animals. They are more fragile and more expensive, so treat them with extra care.

NO. 4 ROUND SABLE BRUSH

Like the no. 4 flat sable brush, this brush is used for detailing and highlighting people, birds, animals, etc. The main difference is that the sharp point allows you to have more control over areas where a flat brush will not work or is too wide. This is a great brush for finishing a painting.

NO. 4 SCRIPT LINER BRUSH

This brush is my favorite. It is used for the very fine details and narrow line work that can't be accomplished with any other brush. For example, use this brush for tree limbs, wire and weeds—and especially for your signature. The main thing to remember is to use it with a much thinner mixture of paint. Roll the brush in an ink-like mixture until it forms a fine point.

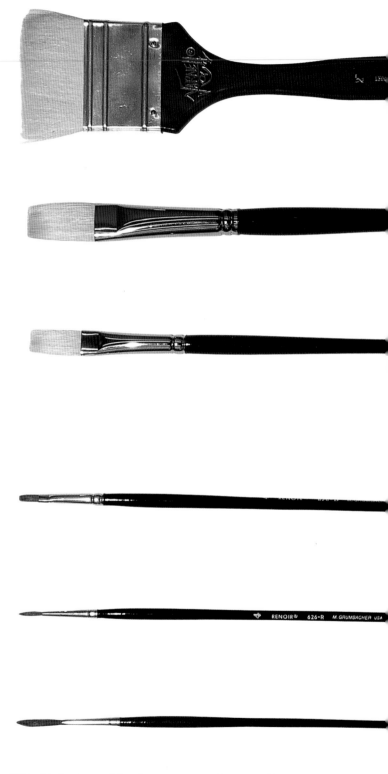

With this basic set of brushes, you can paint any subject.

BRUSH CLEANING TIPS

Remember that acrylics dry through evaporation. As soon as you finish painting, use a good brush soap and warm water to thoroughly clean your brushes. Lay your brushes flat to dry. If you allow paint to dry in your brushes or your clothes, it is very difficult to get it out. I use denatured alcohol to soften dried paint. Soaking the brush in the alcohol for about thirty minutes, then washing it with soap and water, usually gets the dried paint out.

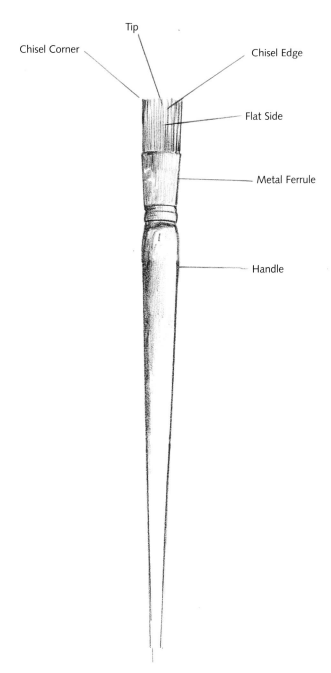

Brush diagram

Tip
Chisel Corner
Chisel Edge
Flat Side
Metal Ferrule
Handle

The Palette

There are several palettes on the market designed to help keep your paints wet. The two I use extensively are Sta-Wet palettes made by Masterson. Acrylics dry through evaporation, so keeping the paints wet is critical. The first palette is a 12" × 16" (30.5cm × 40.6cm) plastic palette-saver box with an airtight lid. It seals like Tupperware. This palette comes with a sponge you saturate with water and lay in the bottom of the box. Then you soak the special palette paper and lay it on the sponge. Place your paints out around the edge and you are ready to go. Use your spray bottle occasionally to mist your paints and they will stay wet all day long. When you are finished painting, attach the lid and your paint will stay wet for days.

My favorite palette is the same 12" × 16" (30.5cm × 40.6cm) palette box, except I don't use the sponge or palette paper. Instead, I place a piece of double-strength glass in the bottom of the palette. I fold paper towels into long strips (into fourths), saturate them with water and lay them on the outer edge of the glass. I place my paints on the paper towel. They will stay wet for days. I occasionally mist them to keep the towels wet.

If you leave your paints in a sealed palette for several days without opening it, certain colors, such as green and Burnt Umber, will mildew. Just replace the color or add a few drops of chlorine bleach to the water in the palette to help prevent mildew.

To clean the glass palette, allow it to sit for about thirty seconds in water or spray the glass with your spray bottle. Scrape off the old paint with a single-edge razor blade. Either palette is great. I prefer the glass palette because I don't have to change the palette paper.

Setting Up Your Palette

Here are two different ways to set up your palette.

PALETTE 1

The Sta-Wet 12" × 16" (30.5cm × 40.6cm) plastic palette-saver box comes with a large sponge, which is saturated with water.

Lay the sponge inside the palette box. Next, soak the special palette paper and lay it on the sponge. Place your paints around the edge. Don't forget to mist your paints to keep them wet.

The palette comes with an airtight lid that seals like Tupperware.

When closing the palette-saver box, make sure the lid is on securely. When the palette is properly sealed, your paints will stay wet for days.

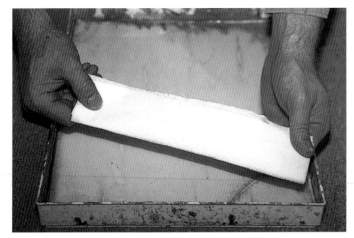

Instead of using the sponge or palette paper, another way to set up your palette box is to use a piece of double-strength glass in the bottom of the palette. Fold paper towels in long strips and saturate them with water to hold your paint.

Lay the saturated paper towels on the outer edges of the glass.

I place my paints on the paper towel in the order shown.

Use the center of the palette for mixing paints. Occasionally mist the paper towels to keep them wet.

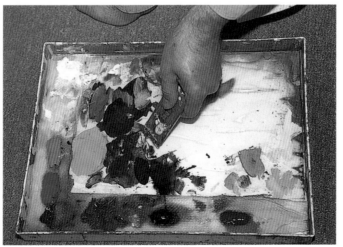

To clean the palette, allow it to sit for thirty seconds in water or spray the glass with a spray bottle. Scrape off the old paint with a single-edge razor blade.

Miscellaneous Supplies

CANVAS

There are many types of canvas available. Canvas boards are fine for practicing your strokes, as are canvas paper pads for doing studies or for testing paints and brush techniques. The best surface to work on is a primed, prestretched cotton canvas with a medium texture, which can be found at most art stores. As you become more advanced in your skills, you may want to learn to stretch your own canvas. I do this as often as I can, but for now a 16" × 20" (40.6cm × 50.8cm) prestretched cotton canvas is all you need for the paintings in this book.

EASEL

I prefer to work on a sturdy standing easel. There are many easels on the market, but my favorite is the Stanrite ST500 aluminum easel. It is lightweight, sturdy and easy to fold up to take on location or to workshops.

LIGHTING

Of course, the best light is natural north light, but most of us don't have this light available in our work areas. The next best light is 4' or 8' (1.2m or 2.4m) fluorescent lights hung directly over your easel. Place one cool bulb and one warm bulb in the fixture: this best simulates natural light.

Studio lights

16" × 20" (40.6cm × 50.8cm) stretched canvas

Aluminum Stanrite studio easel

SPRAY BOTTLE

I use a spray bottle with a fine mist to lightly mist my paints and brushes throughout the painting process. The best ones are plant misters or spray bottles from a beauty supply store. It is important to keep one handy.

PALETTE KNIFE

I do not do a lot of palette-knife painting. I mostly use a knife for mixing. A trowel-shaped knife is more comfortable and easier to use than a flat knife.

SOFT VINE CHARCOAL

I prefer to use soft vine charcoal for most of my sketching. It is very easy to work with and shows up well. You can remove or change it by wiping it off with a damp paper towel.

Spray bottle

Soft vine charcoal

Palette knives

Glazing

You may have seen me demonstrate washing techniques on my TV show or instructional videos. Most of the time, I am referring to a thin wash of water and a particular color that is applied over a certain area of the painting to create special effects, such as mist, fog, haze or smoke. However, the examples here show how to use glazing to create an intense highlight by applying one glaze on top of another. Glazing is truly an old master's technique, and the results can be phenomenal.

Glazing is an important technique to acrylic artists because the paint dries darker than when first applied. By layering one glaze on top of another, an acrylic artist can control the degree of brightness.

This rock is a good subject to study for practicing glazing techniques. Glazing works on any subject that needs to have a brighter highlight and good three-dimensional form.

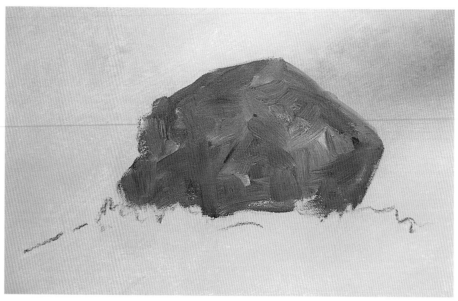

1 Underpaint the Rock
First, underpaint the object with its appropriate underpainting color. Be sure the canvas is completely covered (opaque). For this example, use a combination of Ultramarine Blue, Burnt Sienna, Dioxazine Purple, and a little white. Do not mix them all together to create one color. Instead, mottle them so each individual color will show through the glaze. Use a no. 6 bristle brush for this step.

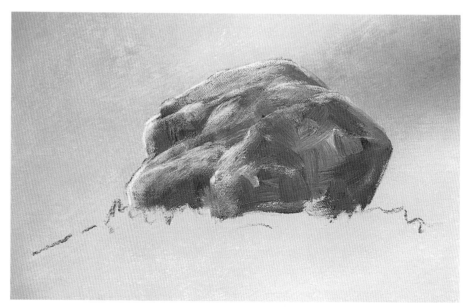

2 Mix Glaze and Apply
Now mix the first layer of highlight color, which I call the "sunshine color." Mix white with a touch of orange and yellow, and thin it slightly with water. The consistency should be like soft, whipped butter. Load a no. 4 flat sable brush with a small amount of paint on the end of the bristles. Gently drybrush the first layer of highlight on the top right side of the rock, carefully blending the highlight color into the underpainting. Be sure the edges are soft, not harsh. Also, some of the background color must show through in order for this process to work.

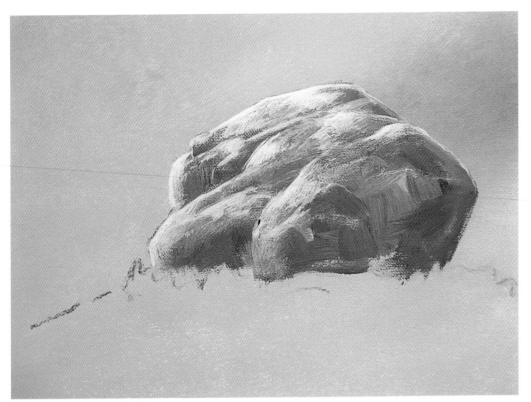

3 Apply Another Layer
This step and the next step are identical to step 2. Use the same brush and the same highlight color. You will drybrush other layers on top of the first. Be sure each layer is dry before applying the next. Remember, this is a glaze and each layer is a thin layer of paint. Notice that these steps make the rock appear brighter.

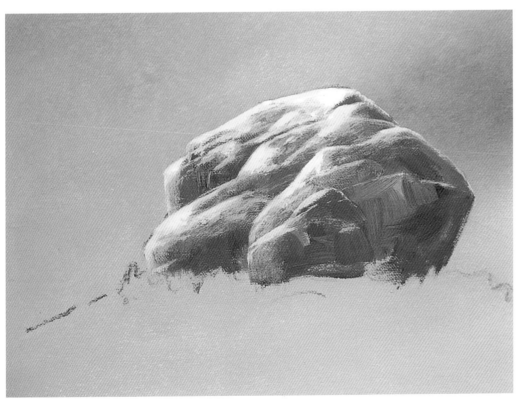

4 Add Final Layer
In this final glaze, you may want to be more selective as to where you place the paint. You do not have to cover the entire highlighted area, but notice that the rock is brighter now than the step before. You can add as many layers of glaze as you wish to create the desired effect.

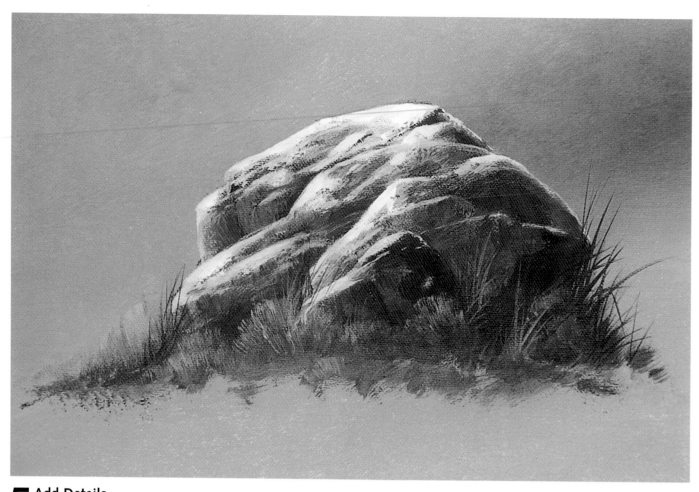

5 Add Details

This is a final detail step and has very little to do with glazing. Seeing the finished product helps you understand the importance of glazing. In this step, you add cracks and crevices, adjust the dark areas in the rock, or other final touches. My best advice is never to finish an object all in one step. It is best to do things in stages. You will have greater success and have more control over your painting.

A Word About My Mixing Technique

The phrases "a touch of this and a dab of that" can make my instructions sound like a cooking show, but I have adopted this style of mixing because it is well suited for my style of painting. There are two main reasons why this style of mixing works so well. First, I am not a formula painter. Many artists have formulas that they use to premix numerous colors and values before they begin a painting. While this technique is widely used, it is very time-consuming and sometimes frustrating. After all that work, the colors and values may not fit into your color scheme. You may end up remixing or adjusting the color.

Using my technique, for example, gray is a base mixture of white, blue, and Burnt Sienna. If I want it to be on the bluish side, I will mix white with blue and a touch of Burnt Sienna. This makes the blue predominant and creates a bluish gray color. If I want a brownish gray, I mix white with Burnt Sienna and a touch of blue. If I want a purple tint, I add a touch of purple. There are literally hundreds of gray combinations based on the colors that are most prominent. This same technique applies for all color schemes. Experiment with this mixing technique, and you will find it very exciting and helpful to your painting experience.

Another reason I prefer my mixing technique is that as a professional instructor who works with people from all over the world, I've learned there are many different brands of paint. Some brands do not match others, and some paints are weaker in pigment than others. There are three different grades of paint: economy, student and professional grade. A formula mixing technique can't work with all of these different paints. With my technique, adding a touch of this or a larger dab of that is a very quick and easy way to adjust a value or color. With a touch of this and dab of that, I am not trying to create a tasty dish, but rather trying to simplify your mixing problems.

My mixing technique doesn't require you to measure out your paint.

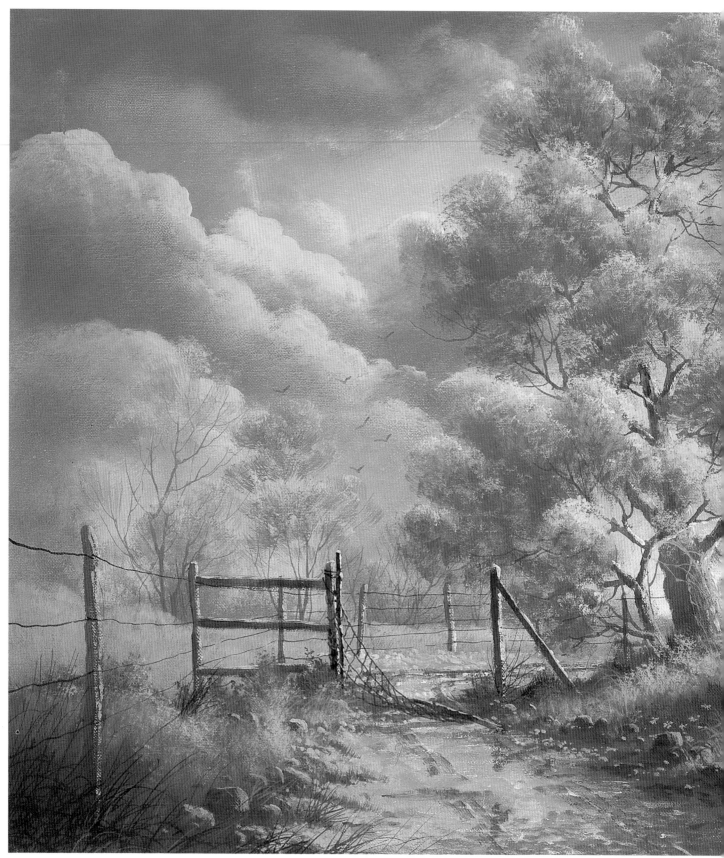

After the Rain
16" × 20" (40.6cm × 50.8cm)

After the Rain

Think back to those moments just after a summer rainstorm: the refreshing smell of clean air and the soft, hazy atmosphere as the sun begins to peek out from the clouds. This painting should bring back those pleasant memories. This is not a difficult painting in terms of subject matter. What makes this an intermediate-level painting is the steps involved in creating the soft, hazy atmosphere. This is an enjoyable painting to start with before moving into subjects that are more technically challenging.

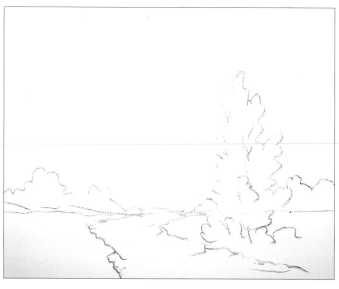

1 Create Basic Charcoal Sketch

It is a good idea to make a pencil sketch on a piece of drawing paper as reference. Then sketch on your canvas a very quick rough charcoal sketch of the basic components of the landscape.

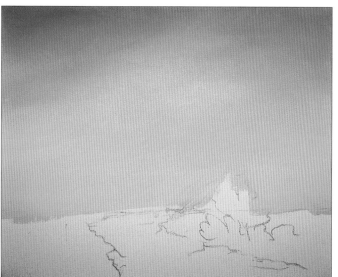

2 Underpaint Sky

This sky requires several layers of paint to create the dramatic effect. First, lightly wet the canvas and apply a liberal coat of gesso with your hake brush. Apply pure yellow to your hake brush and blend upward using large X-strokes, starting at the base of the canvas, until the yellow fades. You want to cover half of the canvas. Rinse your hake brush and load it with blue. Start at the top of the canvas and blend downward until you meet the yellow. Rinse out your brush and use a very light feather stroke to blend the blue and yellow together. It will turn slightly green, but that is to be expected. The main thing is to use light feather strokes in this area.

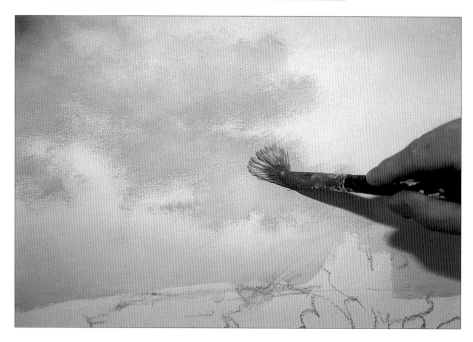

3 Underpaint First Layer of Clouds

In this step, you want to place the basic cloud formations. You will add other layers as you go. Use a no. 10 or no. 6 bristle brush. Mix gesso with a touch of blue, purple, and Burnt Sienna. This mixture will create a soft purplish gray. Add just enough water to make it creamy. Using your no. 10 or no. 6 bristle brush, scrub in the basic shapes and location of the cloud formations. It is important to remember to keep these clouds very soft by using a scrubbing dry-brush stroke. Applying various amounts of pressure to your brush will help create different values and shapes.

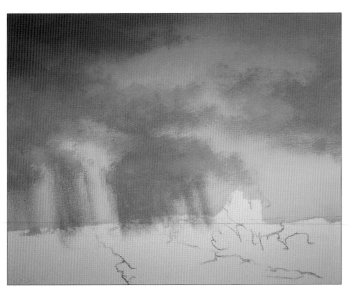

4 Finish Underpainting Clouds

When you have the cloud formations painted, add the vertical rain strokes.

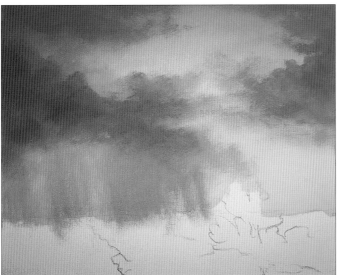

5 Add Darker Clouds

This step is very much like the previous step, except that the values will be darker and the cloud shapes will be more defined. Start with the same mixture as above, then darken it by adding a touch of blue, Burnt Sienna and purple. Use the same stroke and brush. Drybrush in the darker cloud formations. You can also use this value to soften the vertical rain strokes. Remember that the clouds are very important to the composition; be sure they have good negative space and soft edges.

6 Add Lighter Clouds and Intermediate Highlights

Form the clouds with the lighter values of white. Notice that the light is coming in from the right side. I normally use a no. 6 bristle brush; however, some artists prefer the no. 4 flat sable brush. Mix white with a touch of yellow and orange. Highlight only the darker clouds in this step to give them three-dimensional form. Concentrate on negative space and overlapping. Use a drybrush stroke and do not be concerned if the clouds do not appear bright enough. You will highlight them in the next step.

7 Highlight Clouds and Add Background Trees

In this step, you will emphasize the shape of the lighter-valued clouds by using a mixture of white with a touch of yellow. Use a very dry no. 6 bristle brush or even your finger to soften the background clouds with this yellowish white mixture. If you apply the paint thickly, it will stay clean and bright. Next, with the no. 6 bristle brush mix a little purple and a touch of green with enough white to soften it. Carefully push upward with a drybrush stroke and block in some very distant trees. Keep an eye on the negative space.

8 Underpaint Mud Puddles and Background Meadow

First, mix white with a touch of blue and purple and a very tiny touch of yellow to create a bluish gray. Using a no. 6 bristle brush, smudge in the location of the mud puddles. Be sure to cover the large area completely. Add green and a touch of purple to this mixture then haphazardly scumble in the meadow on each side of the road. Be sure the canvas is well covered and move right up to the edge of the road with this color.

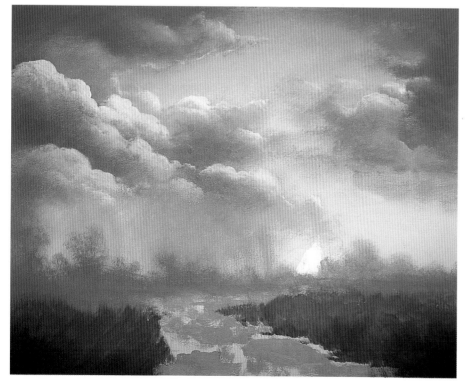

9 Underpaint Middle and Foreground Grass

This is a simple, but important step. You will need a no. 10 bristle brush. Mix white with a touch of green, purple, and Burnt Sienna. Scrub on the color with an upward stroke to suggest grass. As you come into the foreground, add more of the darker colors, but be careful not to get the mixture too green. Remember to keep your strokes loose and rough and cover your canvas completely. It is also important to understand that this is only the underpainting. At this stage, you will not see the finished effect.

10 Underpaint Road and Sketch Tree

Here you will block in the base color of the road. Begin with the areas around the puddles. Mix white with a touch of Burnt Sienna and yellow. Scumble on this yellow ochre color with your no.6 bristle brush until most of the canvas is covered. Add more Burnt Sienna and a touch of purple to darken the mixture. With this darker value, block in the banks on the right side of the road. Use short, choppy comma strokes and gently blend into the flat part of the road. With this step completed, use your charcoal to make a rough sketch of the basic shape of the large tree.

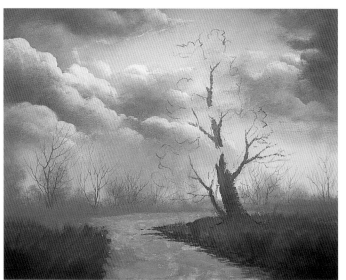

11 Block In Large Trunk and Background Trees

Create a mixture of white with Burnt Sienna, blue and purple, then use a no. 4 flat sable brush and block in the large foreground tree. Apply enough limbs to establish its basic shape. Lighten this mixture with white to change the value, then add plenty of water to thin it to an inky consistency. Use your no. 4 script liner brush to carefully block in the background trees. It is very important that you do not paint these trees too large or too dark. By now, you should have enough experience with the no. 4 script liner brush to create small, delicate limbs. If not, I recommend you practice on a scrap canvas until you are comfortable and confident.

12 Highlight Meadow and Paint Leaves

Use a no. 10 bristle brush to mix Hooker's Green with a touch of yellow and white. Add a little purple to gray it. Load the end of your bristle brush and gently dab the leaves onto the background trees. Be sure not to over-leaf your trees. You want some background to show through. Rinse your brush and use the same dabbing technique with a mixture of white and a touch of yellow or even a touch of Thalo Yellow-Green. Carefully highlight the background meadow following the contour of the land to create a rolling hill effect.

13 Underpaint Leaves on Large Tree

Mix white with green, purple and a touch of Burnt Sienna to make a rich greenish gray. You can use either a no. 10 or no. 6 bristle brush. Mix plenty of color and use the same technique as the previous step: Dab straight onto the canvas. You can apply heavier pressure so the paint will go on thicker. Use good negative space when arranging the clumps of leaves to achieve good eye flow.

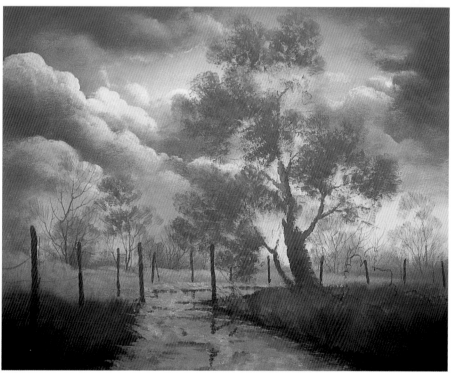

14 Block In Fence Posts and Reflections

Begin this step by lightly sketching in the location of the posts with your soft vine charcoal. Mix Burnt Sienna with a touch of blue and white, then use your no. 4 flat sable brush to block in the posts. Be sure to completely cover the canvas. With this same color mixture, drybrush a rough edge on the backside of the puddles. This technique gives them more depth so they appear to hold water. Now thin the mixture slightly and use short, choppy or wobbly strokes to carefully block in the reflections. The background must show through these reflections.

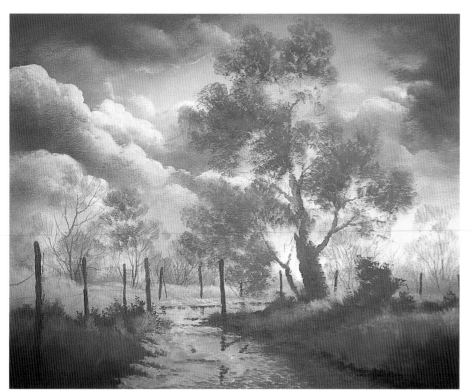

15 Paint Middleground Details

In this step, you will add more bushes, highlight the grass and begin a few details. First, mix green and Burnt Sienna with a touch of purple. Using a no. 10 bristle brush, begin dabbing in patches of brush and tall grass. Next add pure yellow and Thalo Yellow-Green to this color to give it a springlike effect. Dab in the highlights around the darker areas with this color. With a brownish gray color and your no. 6 bristle brush, scrub or dab in some rough areas at the front of the road to suggest dirt or rocks.

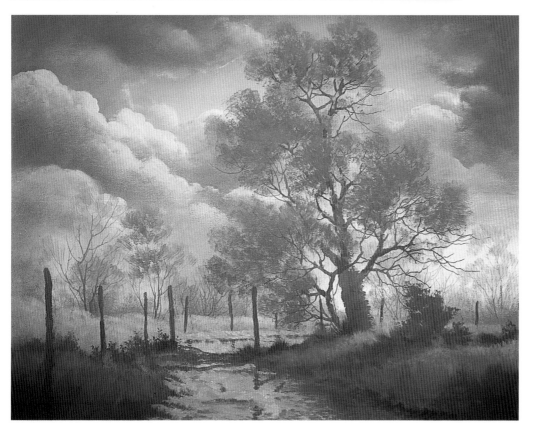

16 Add Limbs to Large Tree and Glaze Painting

The placement of tree limbs is at your discretion. Be conscious of good negative space when painting the limbs, mixing Burnt Sienna and blue with plenty of water to create an inky consistency. Use a no. 4 script liner brush to paint in the smaller tree limbs so the entire tree connects together. After the tree limbs dry, apply a glaze of water and a touch of white and blue. Using your hake brush, paint over the entire background and tree. It will appear milky in color, but will dry soft and transparent.

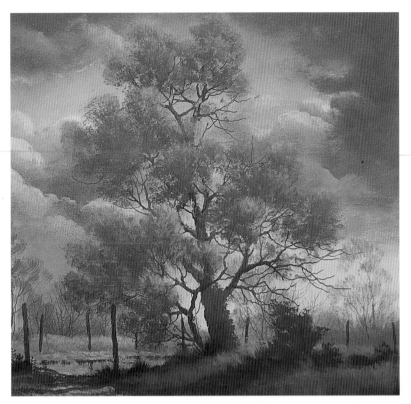

17 Highlight Large Tree, Phase I

At this stage, begin forming the individual clumps of leaves by using an intermediate highlight color and your no. 6 bristle brush. Mix white with touches of yellow and Thalo Yellow-Green. Using a drybrush stroke, begin at the outside edge of each clump and gently pull inward, blending into the darker background. Your stroke should be light in pressure, but the paint should completely cover the dark background. Leave pockets of negative space to create interesting clumps. You will be adding two more layers of highlights to finish the tree.

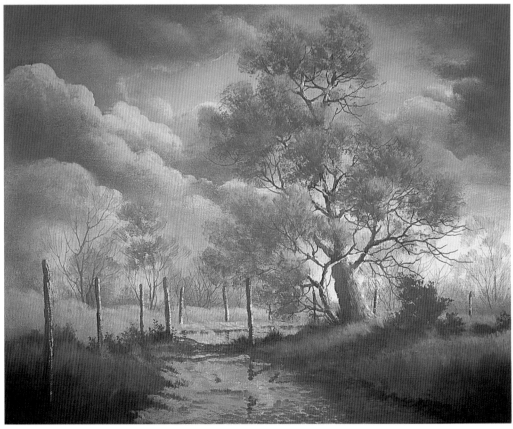

18 Highlight Tree Trunk and Fence Posts

Create a creamy sunshine mixture of white with touches of orange and yellow. I generally use my no. 4 flat sable brush for this step. Use short, choppy, vertical strokes to create the highlights and a suggestion of bark on the large tree trunk. Notice how the highlight gradually fades across the trunk of the tree. Next, put a thin sliver of highlight on the side of each fence post.

19 Detail Road and Block In Rocks

In this step, add details to the road, such as ruts and pebbles, and block in the larger rocks with a mixture of Burnt Sienna and touches of blue and purple. Use a no. 4 flat sable brush to block in the smaller pebbles and larger rocks. Next, using a very dry brush and the same color, skim across the surface of the road with a choppy motion to suggest ruts in the road and through the puddles. Be careful not to make big, thick, dark ruts. You only want to suggest that they are there.

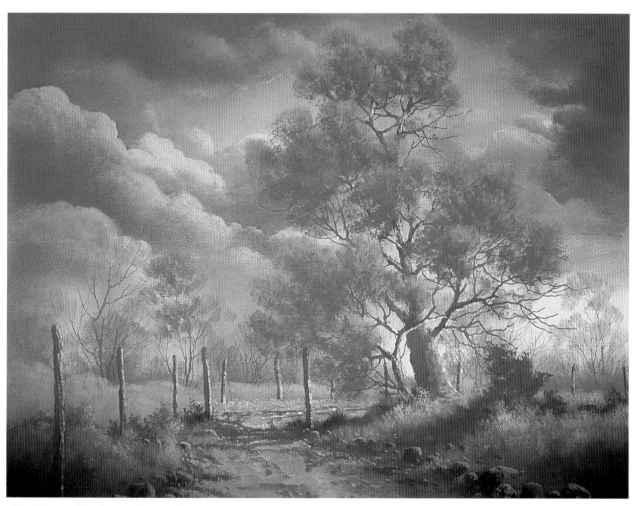

20 Highlight Rocks and Grass

First, mix white with touches of orange and yellow with your no. 4 flat sable brush. Begin highlighting each rock and pebble. Use a drybrush stroke so the paint does not go on too bright or thick. Then, in the sunlit areas of the painting, use brighter yellow or yellow-green highlights. You need to place these highlights on thicker with your no. 4 flat sable or your no. 4 round sable brush to create texture. Use different strokes to suggest various types of grasses, bushes and leaves.

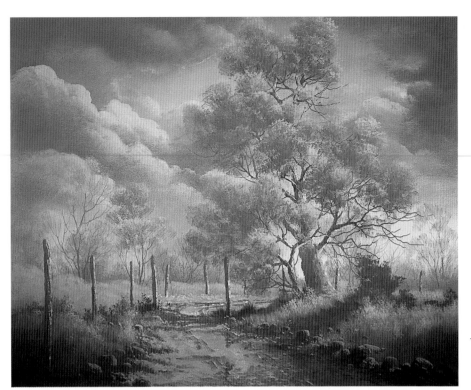

21 Highlight Large Tree, Phase II

In this step, repeat what you did in step 17. The difference is that you are going to use a little brighter color and be more definite with your stroke. This highlight color is a mixture of yellow, Thalo Yellow-Green, and a touch of white. This will "opaque" the finish and make it stand out. Load the very tip of your no. 6 bristle brush and gently dab the brighter highlights only on the very edges of the main clumps of leaves. This requires careful planning because you do not want to overhighlight. Use this same technique for highlighting your foreground bushes.

22 Detail Fence

Now you are getting close to the completion of this painting. In this step, mix Burnt Sienna, blue, purple and a touch of white to soften the color. You want the mixture to be creamy. Use your no. 4 flat sable brush to paint in the horizontal rails of the fence. Next, thin the mixture to an inky consistency and roll your no. 4 script liner brush in the paint until it forms a fine point. This is more difficult than it looks, so you may want to practice first. Be sure to use extremely light pressure as you paint in the fence wire.

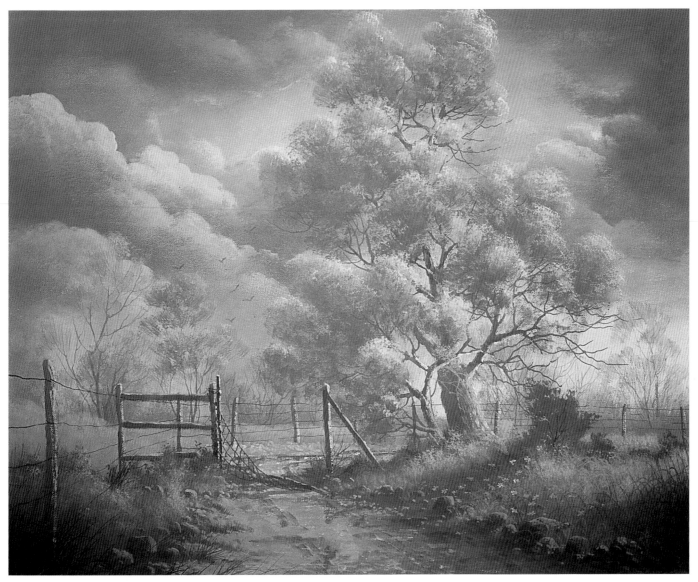

23 Add Final Highlights

In this final step, use your artistic license to add, take away or change things. Notice that I added flowers to accent the painting as well as to balance out the color scheme. I added a few tall, skinny weeds, both light and dark ones. I touched up the road, softened shadows and added a few pure yellow highlights on the very tips of the tree leaves. These details are all simple, but crucial to truly finishing a painting. Be careful not to overdo your final highlights, but do not shy away from adding them. I hope you learned a lot from this painting. It was great fun painting with you.

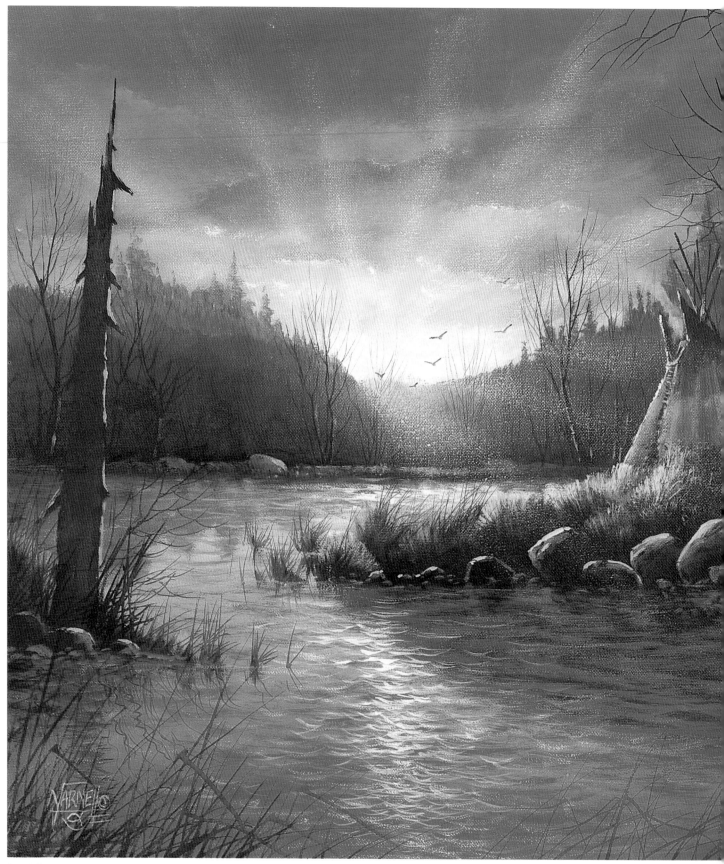

Sunset Camp
16" × 20" (40.6cm × 50.8cm)

Sunset Camp

In the state of Oklahoma where I was born and raised, the Native American culture has very deep roots. These colorful people of the past and present have long been a favorite subject of artists. I am no exception and have spent many hours studying the Native American way of life. This painting, which represents no particular location, has the perfect setting to get across the main point of this lesson: using strong light and contrast to create a dramatic evening sunset. This effect is called backlighting. Every artist needs to be familiar with this effect and how to control it. This very enjoyable painting has tremendous instructional value.

1 Create Charcoal Sketch
Make a rough charcoal sketch of the basic layout of the landscape.

2 Underpaint Base of Sky
First, lightly wet the sky area with water using your hake brush. With the same brush, apply a liberal coat of gesso to this area. While the sky is still wet, double-load your brush with a touch of yellow on one corner and orange on the other corner. Blend back and forth using crisscross or X-strokes. Work your way upward until the horizon color disappears. Be sure to use a light feather stroke to create soft edges. Do not overblend the sky area.

3 Underpaint Top of Sky
In this step, the sky is still wet and you will again use the hake brush. This time triple-load the brush with blue and a touch of purple and Burnt Sienna. Quickly streak these colors across the top of the sky, blending downward using large X- or crisscross strokes, just enough to soften the background. Add a touch of water if necessary to keep the paint creamy as you blend. Do not overblend. You will add other clouds and highlights later. It is OK if darker and lighter spots appear. These add interest to the sky.

4 Underpaint the Water

This step is identical to step 3, except that the lightest part is at the top of the water, and the darkest part is at the base of the water. It is a good rule of thumb to paint your sky and water at the same time to ensure continuity of the color scheme.

5 Drybrush Sunlight in Sky and Water

Create a mixture of white with a touch of yellow and orange and enough water to make it creamy. This is a drybrush technique, so do not put too much paint on your brush. Using a horizontal motion with your no. 6 bristle brush, drybrush back and forth across the base of the sky. When you have completed this step, the horizon should be brighter with no hard edges. The same technique is used to paint the reflection in the water. Be careful not to place too much light in the water.

6 Drybrush Clouds

This is a crucial step. First, use your no. 10 bristle brush to mix white, blue, purple and a touch of Burnt Sienna to create a purplish gray. Be sure the mixture is creamy. Place a small amount on the tip of your brush and scrub in the clouds from right to left, feathering the edges as you go. You can add touches of water and touches of white along the way to help blend into the underpainting. It is desirable to have light and dark areas that create good negative space. Subtle contrasts in values are important for this sky.

7 Underpaint Background Trees and Reflections

Now you will create distant pine trees with your no. 6 bristle brush. Mix white with Hooker's Green and purple to create a greenish gray that will contrast with the light sky. Scumble in the trees, suggesting only their shapes. Do not detail these trees; they are too distant for details. Then scrub the same mixture downward until it fades. Add a little white and a touch more water to the mixture and scrub in the reflections. Make sure the reflections are soft with no hard edges.

8 Add Sun Rays and Highlights to Sky

To add the sun rays, mix white with a tiny bit of yellow. Using a clean and dry no. 6 bristle brush, load a small amount on the tips of the bristles. Find the spot where you want the sun to come from and begin dragging your brush across the surface of the canvas from this point. Apply the paint in a straight line around the circumference of the sun. Use different amounts of pressure on the brush to create more or less light. Heavy pressure allows more paint to stick to the surface; light pressure makes the paint barely noticeable. This step can be repeated as needed.

9 Underpaint Middle Background

The main purpose of this step is to cover the canvas in the middle background and to establish the ground level at the water's edge. The colors are almost the same as in step 7. Mix Hooker's Green, a small amount of purple and a touch of Burnt Sienna. Add just enough white to "opaque" and soften the mixture. Then use your no. 10 bristle brush to scumble this area until the canvas is completely covered. It is OK if this area looks rough and loose as long as the edges are soft.

10 Paint Mist and Block In Shoreline

Next, create a mist or haze that will separate the background from the middleground and create a nice, soft atmosphere. Mix white with a touch of purple and blue. Load a small amount on your no. 6 bristle brush and use a drybrush stroke to scumble a soft hazy mist just below the sun between the two ranges of the trees. Blend the edge of the mist until it disappears. Next, using your no. 4 sable flat brush with a mixture of white and a little Burnt Sienna or Burnt Umber, create a soft highlight. Use short, choppy, broken strokes to suggest a rocky shoreline. Be sure the intensity of the highlight is not too bright.

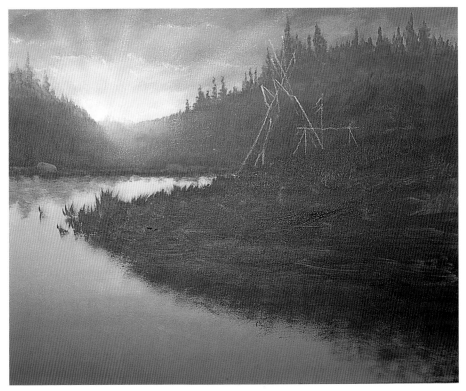

11 Sketch Tepee and Underpaint Foreground

By now, the sketch of the basic shape of the tepee has disappeared. Use a white pencil or white chalk to resketch your tepee. Block in the foreground by mixing and scumbling together on the canvas touches of Hooker's Green, purple, Burnt Sienna and even touches of orange and white here and there. Mix these colors all together on the canvas using a no. 10 bristle brush until the foreground area is completely covered. Then drybrush this color down into the water area to create a soft reflection. You may add touches of water to help make the paint move while you are blending.

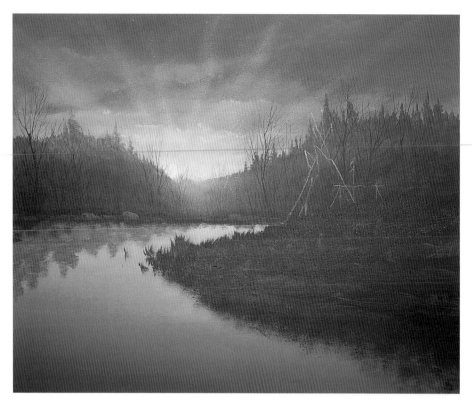

12 Paint Background Trees

Use your no. 4 script liner brush to paint the background trees. I hope that by now you have had enough experience to get a feel for the brush and are able to create the small, delicate, tapered limbs that are necessary for this painting. You will use an inky mixture of water, Burnt Sienna, blue and purple. Create a good variety of shapes and sizes of these trees across the background.

13 Block In Foreground Tree and Grass

In this step, focus on creating a very large, well-balanced, leafless tree that has good negative space. Place this tree in the space to the right of the tepee. This will fill the empty space nicely. Begin by mixing blue, Burnt Sienna and purple. Block in all of the trunk and larger limbs with a no. 6 bristle brush. Then switch to your no. 4 script liner brush and thin your mixture with water to finish out the smaller tree limbs. Be sure to begin each limb at the trunk and gradually taper the branches as you move up or out. Be conscious of the negative space between each limb.

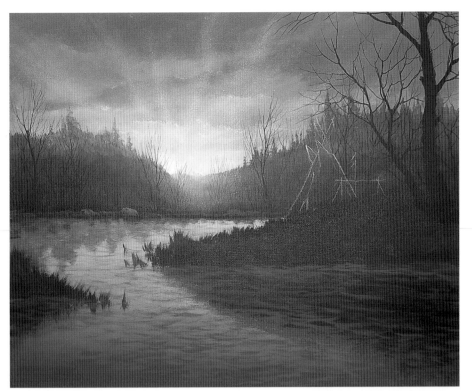

14 Glaze the Water

For this step, mix white, purple and blue with just enough water to create a thin mixture, but don't make it as thin as a wash. The mixture should be slightly darker than the water area color. Use a no. 6 bristle brush and begin at the front of the water area. Turn your brush horizontally and use short, horizontal strokes. Notice that the strokes are closer together at the very front of the painting. As the water recedes into the distance, your strokes should get farther apart, creating a little more movement to the water. Just be very sure the mixture is not too dark or it will overpower the water.

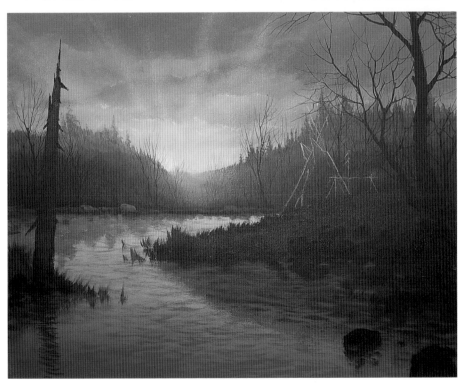

15 Underpaint Rocks and Tree Stumps

This is a simple step. You need your no. 6 bristle brush to block in the basic shape of the large dead tree stump and all of the rocks. Your mixture will be Burnt Sienna, blue and a touch of purple. Using thick paint on your brush, block in the stump and rocks. Be sure your rocks are arranged well. As always, try to create good negative space. Next, with a small amount of paint, use short horizontal strokes to create the reflection of the tree stumps in the water. Notice the reflections are not solid. You must allow some of the background to show through.

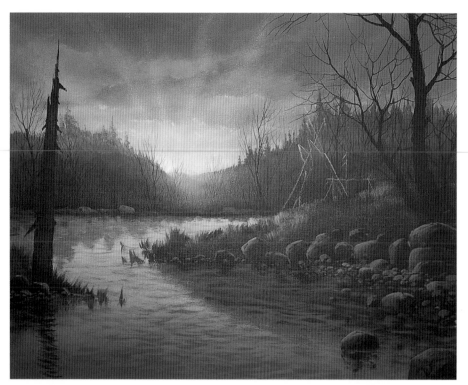

16 Highlight Rocks

This step requires patience and determination. Mix a sunshine color of white with a touch of orange. I usually add a slight touch of blue or purple to gray it. Using the no. 6 bristle brush or a no. 4 flat sable brush, begin highlighting each individual rock. However, do not put the paint on too thick, or the highlight will become too bright. It is best to thin the paint slightly with water and build the highlights up in layers. (See Glazing on pages 18-20.) After you apply the first layer of highlight and it dries, add another layer. Repeat this process as many times as necessary until you have the desired brightness.

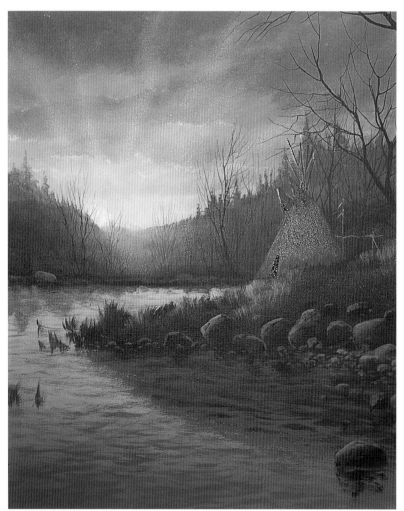

17 Underpaint Tepee

This is a very easy step. Use your no. 4 flat sable brush to haphazardly apply white, Burnt Sienna and a touch of blue and purple to the tepee. Mix the colors on the canvas, but do not overblend. The mixture should be a grayish tone that stands out from your background. At the top of the tepee, add more blue and Burnt Sienna to darken the color of this area. The top of the tepee should be a blacker color because that is where the smoke comes out of the opening.

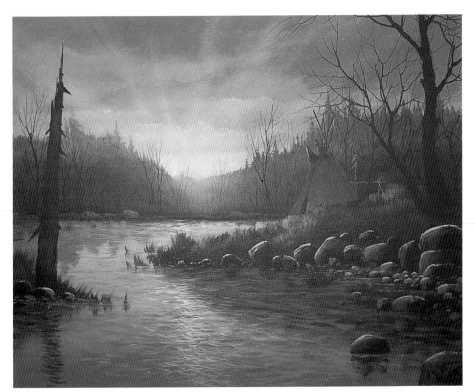

18 Paint Sunlight on Water and Rocks

Next, accent the water to give it some sparkle and accent the rocks to give them more of a glow. For the water, mix yellow and white. Use a no. 4 round sable brush to apply short, horizontal comma strokes in the middle of the water where the sun reflects onto it. Then add orange to the same mixture and use your no. 4 flat sable brush to add accent highlights on the top edges of the rocks. This time the highlight can be intense. You want these highlights to create a strong glow.

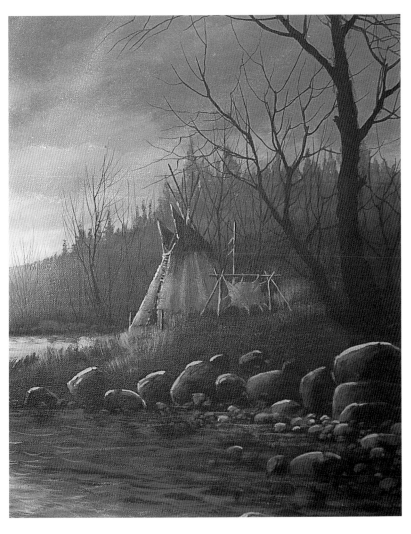

19 Detail Tepee

This is a fun step, although it takes a bit of patience. First, take your no. 4 flat sable brush and mix Burnt Sienna, a little white and a touch of orange. Blend from left to right with a dry brush until the tepee has a three-dimensional form. Increase the brightness on the left side of the tepee until it looks sunlit, then do the same thing to the stretched hide on the drying rack. Use your no. 4 script liner brush with a touch of yellow and white to accent the edge of the tepee and the support poles. Finish by painting a design or other details on the tepee using your artistic license.

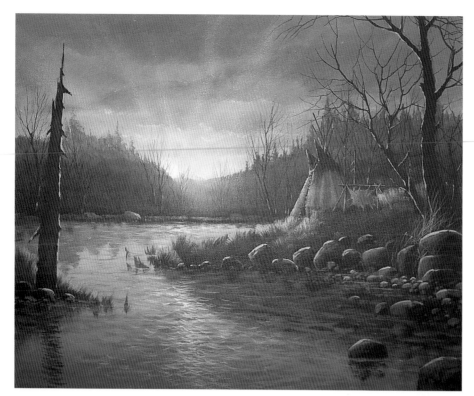

20 **Highlight Trees and Grass**
Since you are working with a backlit situation, most of the highlights will be thin slivers of light on the very edges of the tree trunks. I prefer to use a no. 4 round sable brush for this step. Mix white and orange with a little water to create a creamy mixture. Next, use short, choppy, thin strokes to highlight the edges of the main tree trunks. Then thin the mixture with a little water and add some yellow. Switch to a no. 4 script liner brush and paint in a few light weeds around the tree trunk and rocks. These weeds should really stand out against their dark background, which will add to the sunlit glow.

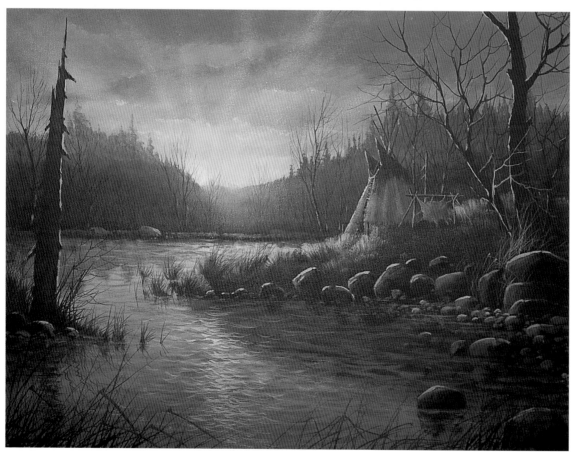

21 **Add Foreground Weeds and Brush**
For this step, use a no. 4 script liner brush and a thin, inky mixture of Hooker's Green with a touch of Burnt Sienna and purple. When you paint in these foreground weeds, use flexible strokes that overlap each other and vary in length and thickness. Remember to pay close attention to the negative space between each weed and limb. Do not be timid; paint plenty of weeds that overlap one another.

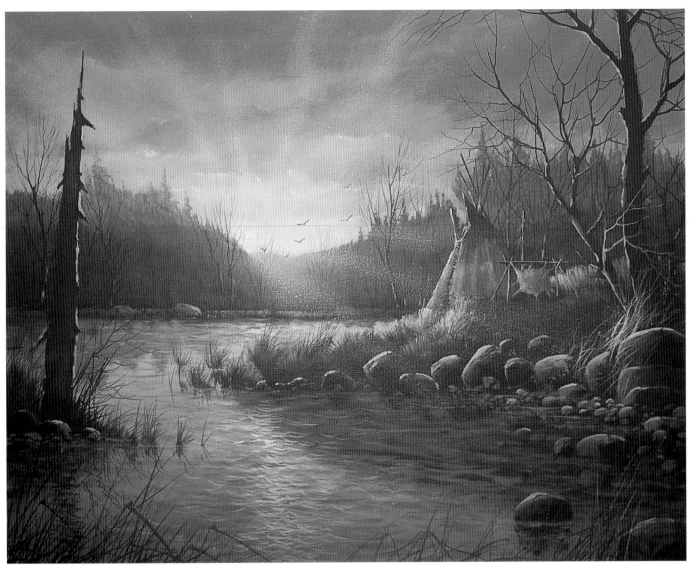

22 Add Final Highlights and Details

This step finishes the painting. Use a no. 6 bristle brush with a touch of white and yellow to drybrush in the final sun rays. Move forward to where the sun hits an object. It is a clever idea to brighten the edges of lit objects with a mixture of yellow and white or orange and white. Add your own details, such as birds or smoke from the tepee. Brighten the weeds or even add a few flowers to make this painting seem to literally come alive. One word of caution: Do not overhighlight or overdetail. Simplicity is the key to a successful painting. I hope you enjoyed this painting experience. It was certainly a great joy sharing it with you.

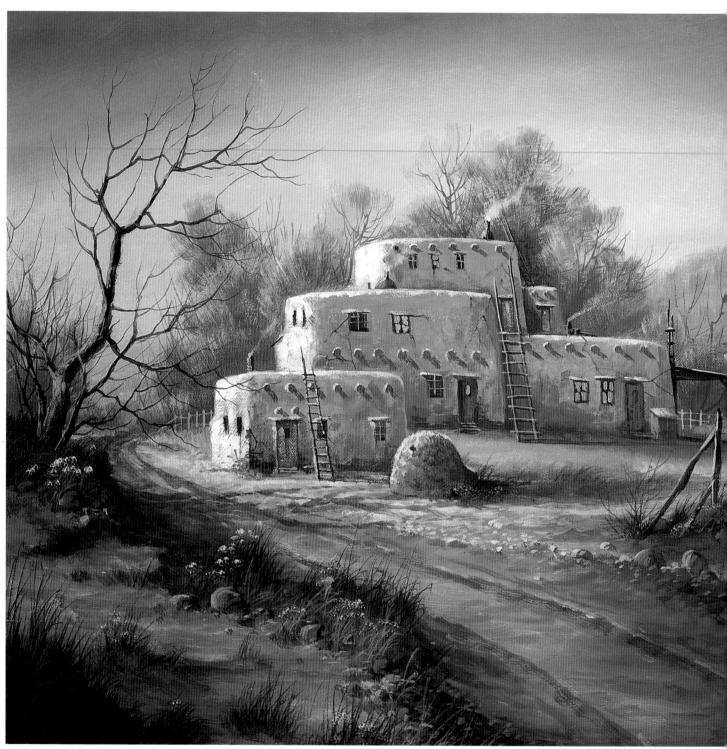

Adobe Village
16" × 20" (40.6cm × 50.8cm)

Adobe Village

For many years I lived in and around the Taos, New Mexico area, a true artist's paradise. Just north of Taos is one of the oldest inhabited adobe pueblo villages in America, a true architectural wonder. Artists from all over the world go there to study, paint and admire the colorful Pueblo culture. I am no different. This village is one of the reasons New Mexico is called the "Land of Enchantment." New Mexico is a year-round classroom for any artist because of its soft earth tones that change with the seasons. Here you can become inspired to create endless compositions and color schemes. It is not just the buildings that are so interesting, but also the people. On any given day you may see an old woman hanging up her beautiful rugs or working on a piece of pottery, and men working on the rooftops or repairing the weathered walls. You may see fresh bread baking in one of the adobe ovens. I could go on and on. I hope that you enjoy this painting and that it inspires you to visit this village in person if you get the opportunity.

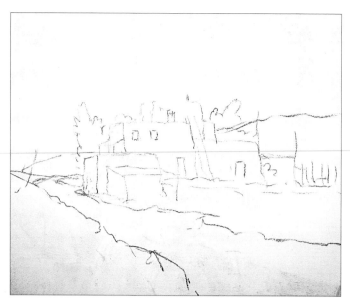

1 Create Charcoal Sketch

This painting is a bit more complicated than the previous ones, so a more accurate sketch is necessary. Use no. 2 soft vine charcoal and sketch in the basic shapes of the adobe buildings. Details are not important.

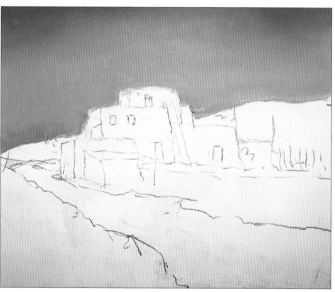

2 Underpaint Sky

There will be a simple sky in this painting. First, lightly wet the sky area with water using your hake brush then apply a heavy coat of gesso to this area. While the gesso is still wet, begin at the horizon with Cadmium Red Light and blend halfway up in the sky area using the hake brush. Apply Ultramarine Blue to the top of the sky and blend downward until the two colors meet. Rinse your brush and gently blend until you have a very soft, clean sky. Do not overblend because the colors should stay very clean.

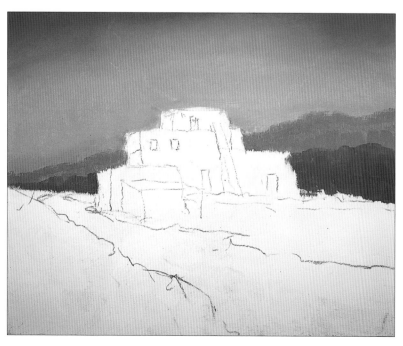

3 Underpaint Background Hills

In this step, you will want to create two layers of distant hills. Mix white with a touch of Hooker's Green, a little purple and a touch of Burnt Sienna. This will be the first layer, which should be slightly darker than the sky. Use a no. 6 bristle brush and a downward drybrush stroke. These distant hills are tree covered, so it is acceptable for the edges to be rough as long as they are soft. Next, add a touch more of green, Burnt Sienna and purple to the mixture. Repeat the above step to create a smaller, closer hill.

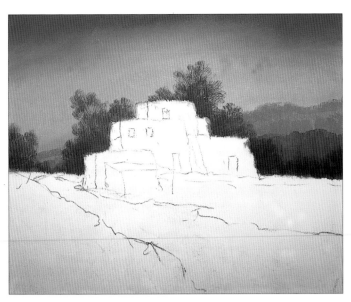

4 Block In Background Trees

Next, you will paint a variety of background trees to create a nice backdrop for the adobe village. First, mix a base color of white, Hooker's Green, red and yellow. Then add more yellow, red or green to create whatever background color you want. Use your no. 6 bristle brush to drybrush in the shapes of your trees using a very soft, downward stroke starting at the top of the trees. Be sure to leave good negative space; you will highlight these background trees in another step.

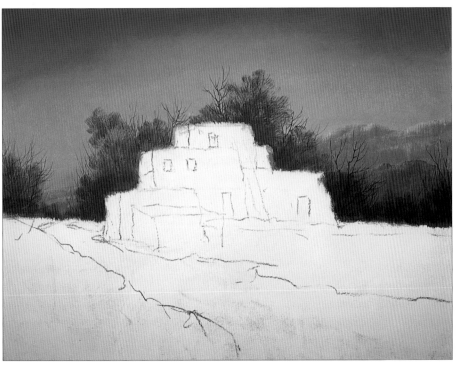

5 Highlight Hills and Add Tree Limbs

First, mix white with a touch of yellow and orange. Then, using your no. 6 bristle brush and a downward drybrush stroke, highlight the distant hills. Add a touch of orange to the highlight color and apply to the closer hill. Now you will need your no. 4 script liner brush and a mixture of Burnt Sienna with touches of blue and purple and a small amount of white to soften the color. Add plenty of water until the mixture has an inky consistency. Paint in a few tree limbs across the back of the painting, but do not paint in any larger trees.

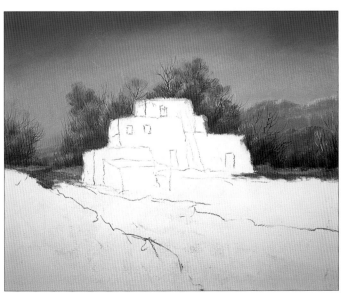

6 Highlight Trees and Underpaint Middleground

Add three-dimensional form to the trees by adding one or two layers of highlight. I usually use white with a touch of orange, yellow or red. You can even use these colors in their pure form if you are careful. Since this is the fall of the year, you want plenty of color without overdoing it. Use a no. 6 bristle brush and a drybrush stroke to follow the contour of each tree, keeping in mind that the sun is coming in from the left-hand side. Next, move down into the middleground and scumble in some brush and grass. You may add a touch of Burnt Sienna for darker values.

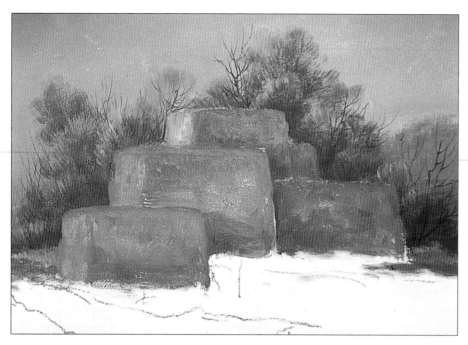

7 Underpaint Buildings

Next, use a no. 6 bristle brush and a mixture of white, Burnt Sienna and a touch of yellow for the base color. Add a touch of purple for the shadowed areas and more white for the lighter areas. Apply a thick layer of paint to your brush and scumble in the underpainting. Keep the corners rounded and soft, and be sure the canvas is well covered.

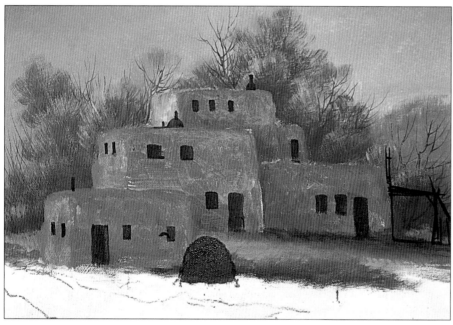

8 Block In Doors, Windows, and Miscellaneous Items

This is a simple step, but important, because you need to establish the location of the doors and windows before you can begin the details. Also, block in other items, such as the lean-to, the fence and the ovens. For all of these, I used a mixture of Burnt Sienna, purple and a touch of blue. Use your no. 4 flat sable brush to paint them in completely. You will vary their colors in future steps.

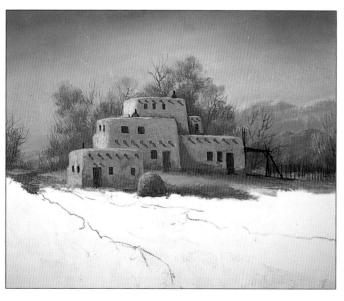

9 Detail Buildings, Phase I

Begin refining the buildings by adding shadows, highlights and other details. The best way to describe what to do is to have fun, yet be careful. If you take a mixture of white, purple and a touch of Burnt Sienna that is fairly thin, you can use a no. 4 flat sable brush and scumble over the underpainting, leaving some of it showing through. This creates a claylike color. Darken the mixture with a little purple, blue and Burnt Sienna and use it to darken the shadow areas. Next use yellow and white to highlight the sunlit sides and tops of buildings. Then go back to the dark color and block in the *vegis* (wooden beams) and their shadows. You will continue adding darker and lighter values, along with more details in future steps.

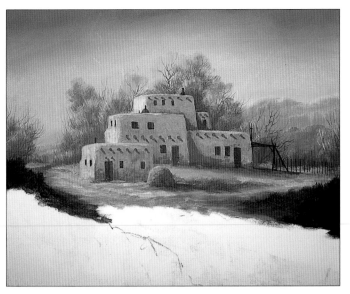

10 Underpaint Middle Foreground

This step is important for establishing the mid-range values. Use a combination of earth colors along with touches of white. Use your no. 6 bristle brush to scrub on the dirt area with choppy, horizontal strokes. Be sure to leave it rough and loose to resemble dirt. Then, with Hooker's Green, Burnt Sienna and a touch of purple, drybrush in some brush on each side of the middleground. Remember that this is an underpainting, so you will not add any details or highlighting.

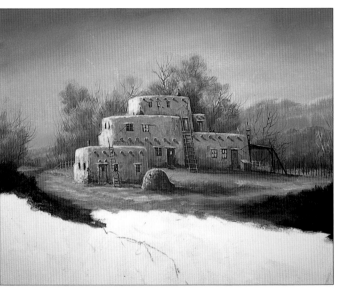

11 Detail Buildings, Phase II

In this step, you will put most of the final details on the buildings. Use your imagination to place all kinds of items around these buildings, including ladders, woodpiles, cracks in the adobe, brightly colored doors, etc. First, add the physical details to the walls. For the cracks, use a thinned Burnt Umber and your no. 4 script liner brush. Drybrush a few darker values on the shadow side and brighter highlights on the sunlit side. After you are satisfied with the walls, you can begin adding the objects on the walls and roofs. I mostly used the no. 4 flat and no. 4 round sable brushes for this step. Again, use your imagination and have fun, but do not overwork the details.

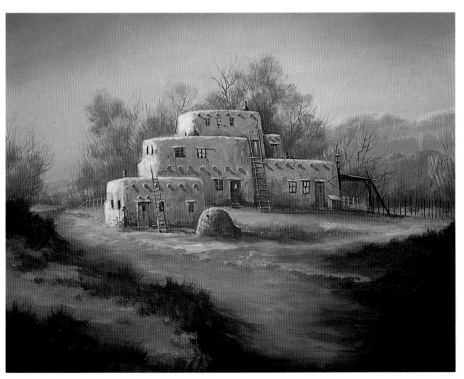

12 Underpaint Foreground

Here you will underpaint the road and other components of the foreground. This step is identical to step 10. Scrub in the rest of the road, keeping it rough and loose. Be sure to darken the road as you come forward by adding more Burnt Sienna and purple. Then add patches of grass and dirt on each side of the road. The most important thing to remember here is to keep the value system in the right order and to cover the canvas completely.

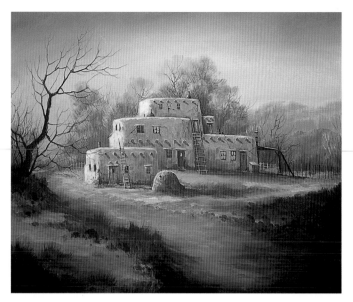

13 Underpaint Dead Tree and Rocks

Here all you need to do is block in the dead tree and a few small rocks on each side of the road. For the rocks, mix Burnt Sienna, blue and purple. Use your no. 4 flat sable brush to block in the rocks. You do not want too many rocks, just enough to add interest to the foreground. Thin the mixture to an inky consistency, and using your no. 4 script liner brush, carefully block in the dead tree. Remember the rules of good negative space. The tree is very important to the composition, yet it must not overpower the painting.

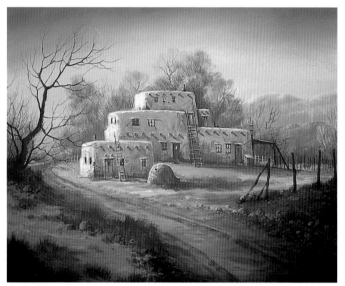

14 Begin Middle and Foreground Details

The painting will begin to come together with these intermediate details. The best brush for all of these steps is the no. 4 flat sable brush. First, highlight the rocks and add pebbles with a mixture of white, a touch of orange and a little touch of purple to gray it. It should not be too bright; you can always increase the highlights later. Now with a very dry brush, barely skim the surface of the canvas and block in the ruts. Notice how they become wider apart as they come closer to us. Let some of the background show through so that the ruts are not too dark and solid. With the same dark value, block in the fence posts. You may want to sketch them in first with soft vine charcoal.

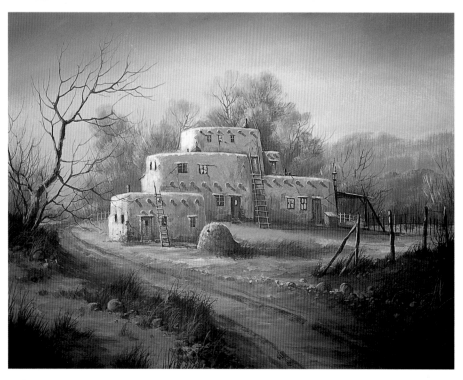

15 Add Final Highlights

Now it is time to search through your painting for areas that need brighter highlights, such as rocks, pebbles, clumps of grass, tree trunk, fence posts and the sides of the buildings. I usually mix two different sunshine colors. The first mixture is white with a touch of orange and the second mixture is white with a touch of yellow and orange. You want these mixtures to be creamy. Using your no. 4 flat or no. 4 round sable brush, carefully pick the areas and objects that need more light and apply one or two layers of highlights until you get the desired effect.

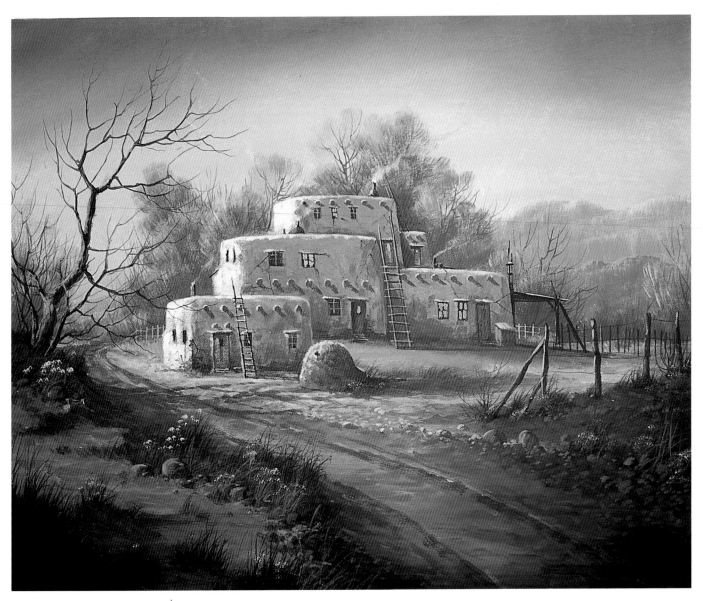

16 Add Miscellaneous Final Details

Finishing a painting can be frustrating because we are not always sure when to stop. All that is necessary in this painting are simple accent highlights to suggest flowers, adding tall weeds or highlighting various areas of the painting to make them stand out. I usually begin with my background and work forward, making any necessary adjustments. I know I need to stop when I begin looking for a reason to keep painting. That is when I am about to overwork the painting, so that is when I need to stop.

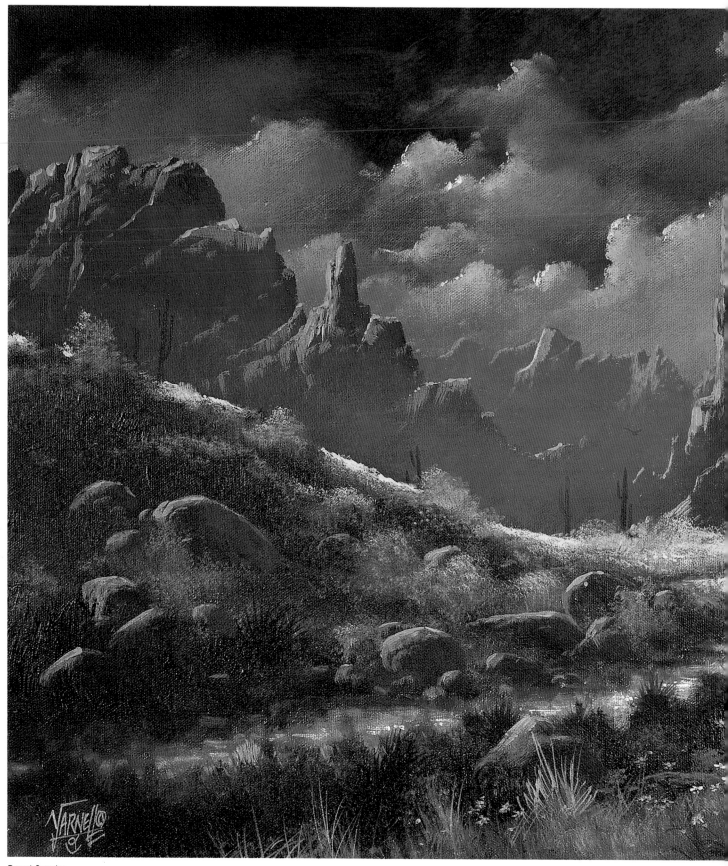

Desert Surprise
16" × 20" (40.6cm × 50.8cm)

Desert Surprise

There is a place in the West called the Four Corners where Arizona, Colorado, New Mexico and Utah all meet. The rock formations found here are like something you would see on another planet. This is a very isolated, rugged place and like so many areas out West, it attracts artists from all over. I spent a twenty-four-hour period at this location to study the effects of the sun from sunrise to sunset. I was overwhelmed by the extreme light and atmospheric changes. One moment there would be an explosion of intense thunderheads with lightning and rain. The next moment a rainbow with dramatic rays of sunlight was visible. Before the show was over the sky cleared, then melted into a stunning red, yellow and orange sunset. This is a great painting for studying light, shadow and contrast. I promise that this will be a rewarding painting experience.

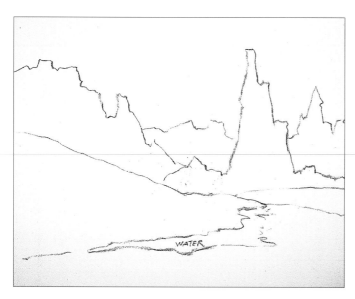

1 Create Charcoal Sketch

Make a rough sketch of the mountain range and the basic land formations.

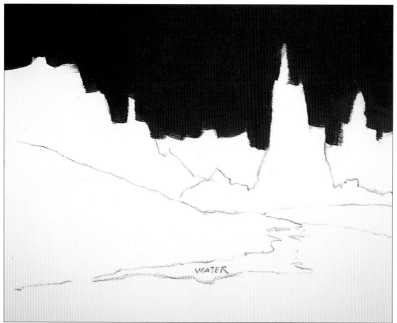

2 Underpaint Sky

This painting features a very dark, late evening sky. It is best to paint the entire sky with a darker value, then let it dry and dry-brush on the other values of colors to create clouds. With your hake brush, wet the sky, then mix Ultramarine Blue, a touch of purple and a touch of Burnt Sienna. The color will be very dark, so add a small amount of gesso to slightly lighten and "opaque" the mixture. Next paint the entire sky with a liberal coat of this color. Then allow the background to dry.

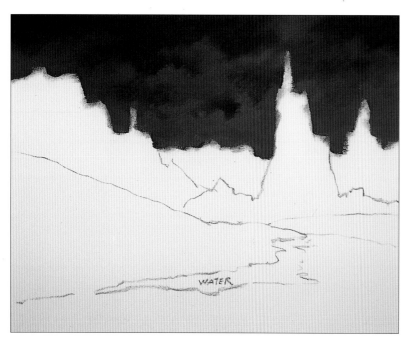

3 Drybrush Cloud Formations

When the sky is dry, mix the cloud color from the same dark background color. Add a touch of white and a touch of red to this mixture, which will create a soft, warm gray tone that is perfect for drybrushing the clouds. Load a small amount of this color on the tip of your no. 6 bristle brush. Begin using a scumbling stroke to gradually blend the clouds into the background. In the next step, you will highlight these clouds to give them a three-dimensional effect.

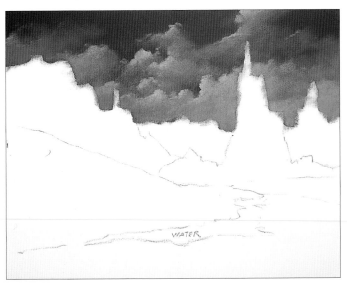

4 Highlight Clouds

Here you have a couple of options. You can use pure white with a touch of red or you can use the mixture from step 3 with a touch of red and white. Your light source is coming from the left. Use your no. 6 bristle brush to gently drybrush highlights on the upper left side of each of the clouds. Highlight only the clouds that you want to have more form. Be careful not to over-highlight. You want the overall effect of a late evening sky. This may in fact be more of a moonlight effect.

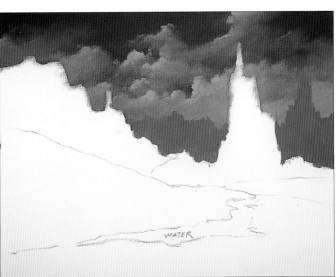

5 Underpaint Background Mountains

You may need to resketch your mountains, but if you have the confidence, you can block them in with your brush as you go. Mix blue, a touch of Burnt Sienna, a touch of purple and whatever amount of white is necessary. This first layer should be slightly darker than the sky. Block in the basic mountain shapes with your no. 6 bristle brush. Be sure they are composed well with interesting pockets of negative space.

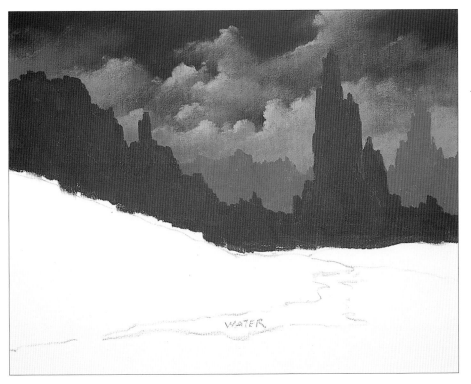

6 Underpaint Middleground Mountains

This step is identical to the previous one, except the value of the color should be slightly darker than the previous mixture, and you want to be a little more precise with the shape of the rock formations. I prefer to use a no. 6 bristle brush. Apply a thick layer of paint to completely cover the canvas.

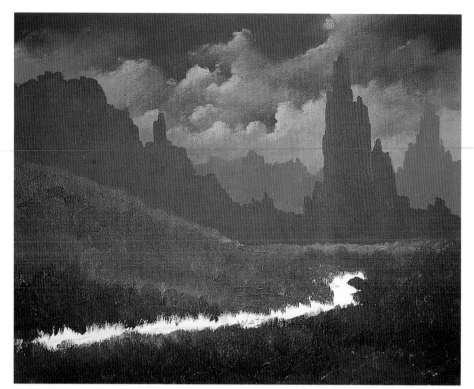

7 Underpaint Middle and Foreground Grass

This is a fun and loose step and a good place to work out your frustrations. Mix on your palette green, half as much Burnt Sienna, a fourth as much purple, and a touch of white. This should be a rich, dark olive green. Using your no. 10 bristle brush and an upward scumbling motion, underpaint the entire foreground, adding a touch of red, yellow, orange or even Thalo Yellow-Green. This will add a little more diversity to the color. Again, be sure the canvas is completely covered. It is OK for the grass to have some texture.

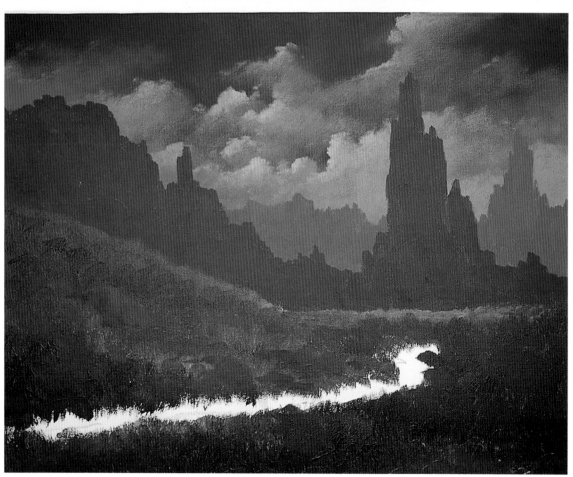

8 Underpaint Middle and Foreground Rocks

This is a very simple step. Mix Burnt Sienna, purple, a touch of blue and a touch of white. Then, with your no. 6 bristle brush, simply block in the location of the rock formations. Do not worry about details or highlighting, just the basic shapes and locations.

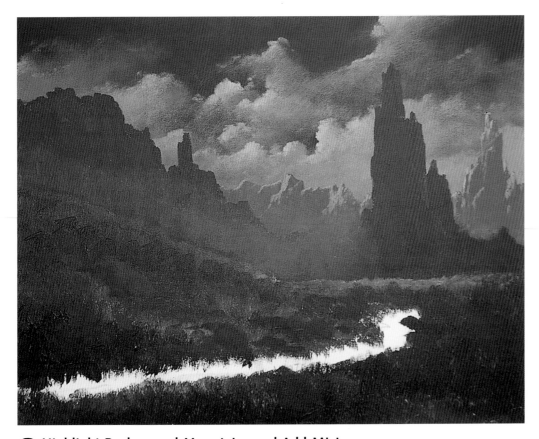

9 Highlight Background Mountains and Add Mist

The highlight mixture is orange with a touch of white and red. Use your no. 4 flat sable brush and gently highlight the very tip and left side of the rock formations. These are vertical rock formations, so use short, choppy, vertical strokes when applying the highlights. Now clean out your brush and mix white with a touch of blue and purple. Drybrush in the mist at the base of the background and middleground mountains. Use a scumbling stroke and be sure the mist blends into the mountains so there are no hard edges.Repeat this step as necessary to get the desired effect.

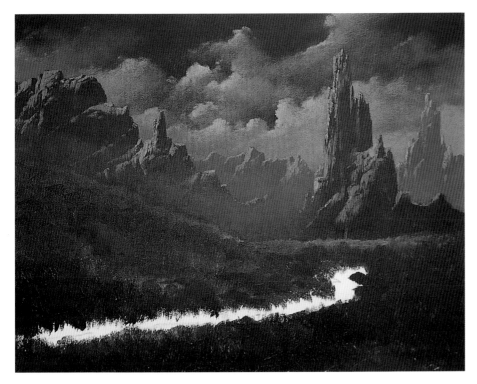

10 Highlight Middleground Mountains

Mix orange with a touch of red and white as in the previous step. Using your no. 6 bristle brush or your no. 4 flat sable brush, apply a series of choppy vertical strokes to create a rugged, rocky mountain. You want to create a very dramatic light effect, so the paint must be applied thickly and opaquely. Try not to overhighlight the rock formations. You want to suggest their forms and leave plenty of dark pockets of space. This is like putting a silver lining on a cloud to make it stand out against a darker background.

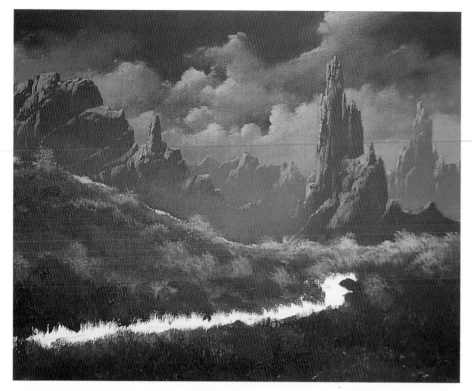

11 Highlight Middleground Grass

Now you will begin some of the intermediate details. Scatter spots of bright greenish yellow light throughout the middle- and foreground. Thalo Yellow-Green will be the base color, with touches of orange, yellow, Burnt Sienna and Hooker's Green to add variety to the highlights. Do not be timid in experimenting with various shapes to create bushes or taller grasses. This is also a good place to experiment with different brushstrokes. For the most part, work with a dry brush. You will add final highlights and details in the final steps. The no. 10 or no. 6 bristle brush works best for this step. Try dabbing, smudging or scumbling on these highlights.

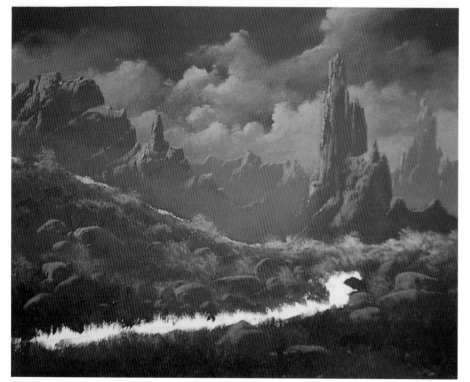

12 Highlight Rocks

The proper highlight on the rocks will set the stage for the intensity of the final highlights you will use in the foreground. Mix white with a touch of red and orange. Add a small dab of blue to gray the mixture because you are not yet ready for the final brighter highlights. Use a no. 4 flat sable brush to skim the top left side of each rock formation. Highlight them just enough to make them stand out against the dark green background. This is where contrast is so important.

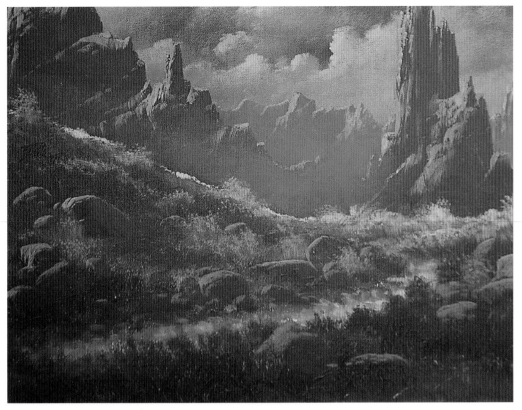

13 Block In Water
For this step, you will create a soft bluish gray. With the no. 6 bristle brush, mix white with touches of blue, Burnt Sienna and purple. With this mixture, block in the water with relatively thick paint. Notice that there are dark and light areas. Simply add more blue and Burnt Sienna or purple for the darker areas and add white for the lighter areas. Use loose, choppy strokes and be sure to use a dry-brush stroke to blend the edges into the banks. You will not need to do much more to the water, so do not overwork this area.

14 Detail Foreground Grass
Now you will create more close-up details. First mix a dark green mixture of Hooker's Green, a touch of Burnt Sienna and purple. Mix until it becomes very creamy, then block in the main shape of the yucca bush on the right using a no. 4 round brush. Now use your no. 4 script liner brush to pull out the long shoots for the plant. The yucca is a nice "eye-stopper" for this side of the painting. Mix Thalo Yellow-Green, yellow and a touch of the dark green mixture, and use your script liner brush to paint the light contrasting weeds in the foreground. Be sure to create a variety of shapes and sizes. Do not be afraid to add some darker weeds as well, because strong dark and light contrasts are the key to the drama of this painting.

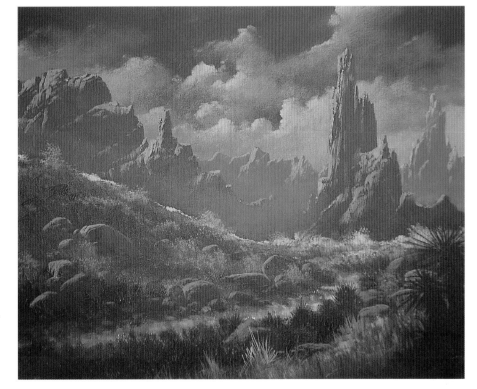

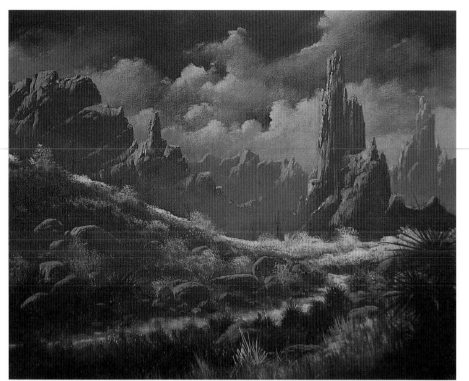

15 Begin Final Middleground Details

Beginning in the middle of the painting, start dabbing on some complementary colors (oranges, yellow-orange, reds, etc.) to suggest flowers and other desert vegetation. Adding these details at the base of the rocks will help settle them down in the painting. The red is very important to the overall complementary color scheme, but notice how subtle the color is. Then use the dark green mixture that you used before to add a few small silhouetted cactus in the background.

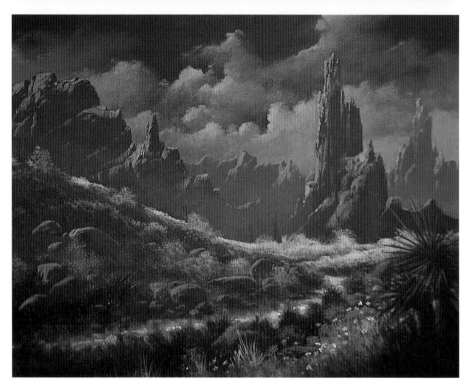

16 Add Final Details in Foreground

This is where you might get carried away with detail, so please be cautious. You will add more flowers and highlights in this step. You can add any kind of flower you desire. I painted white daisylike flowers and some bluish flowers to bring out the color in the background. Color composition is not just about complements, but also about repeating certain colors to unify the painting. The bluish flowers repeat the bluish haze in the background. You can get away with using pure colors if you are careful, such as touches of pure red, orange or Thalo Yellow-Green. Mix a little white with the colors to help them really stand out.

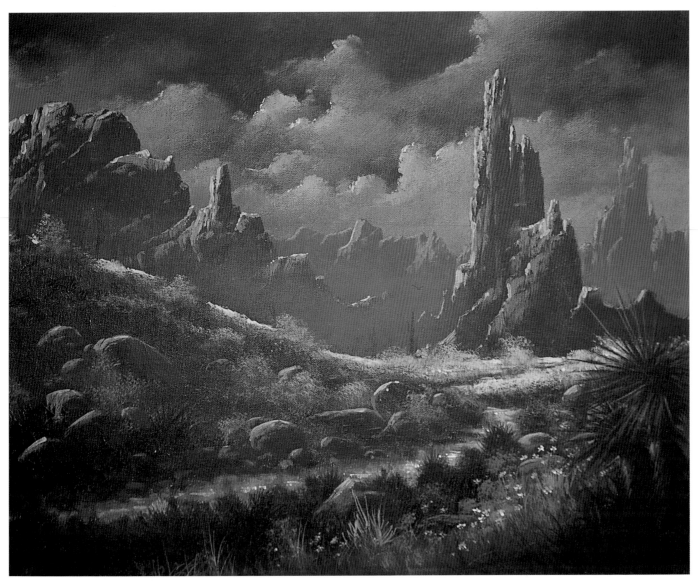

17 Create Final Highlights on Rocks, Grass and Mountains

This is the final step, although it may not even be necessary if you are satisfied with your painting. However, because of the extreme light and dark contrasts, you may want to add a final layer of highlights on the very edges of the clouds, mountains, grass and rocks. Your highlight mixture will vary with each object and area. Then using whichever brush works best, paint the highlight on relatively thick so it stays opaque and bright. Remember, you are only intensifying existing highlights, not adding new ones.

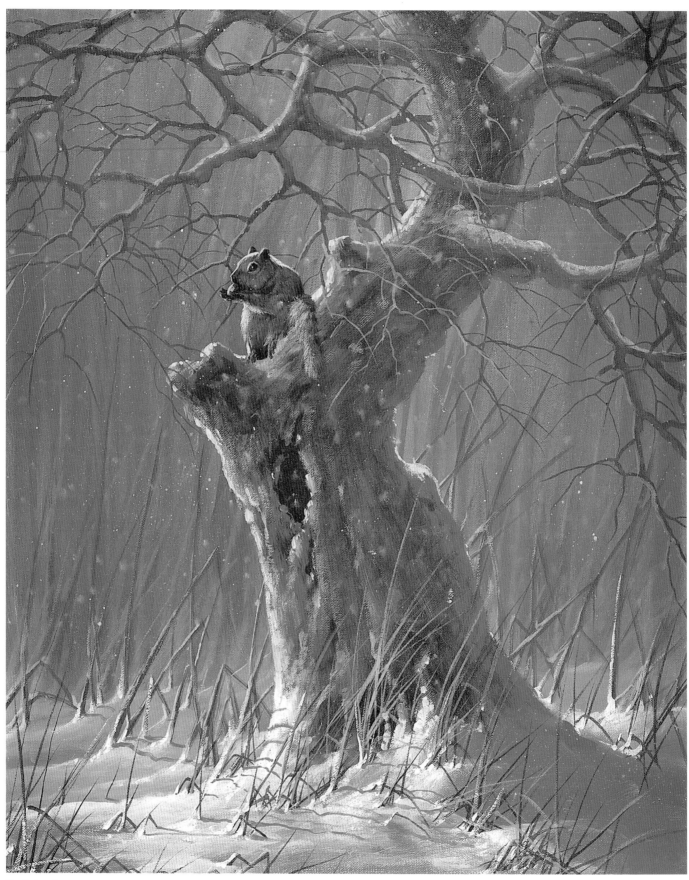

The Nutcracker
20" × 16" (50.8cm × 40.6cm)

The Nutcracker

This painting will challenge you, not because it has a lot of depth, a dramatic sunset or some strange and unusual subject matter, but because of the snowy atmosphere on a cold winter's day. You will need to understand negative space and how to handle the script liner brush to create delicate tree limbs. If snow is something you enjoy, then learning the procedure for creating soft, sunlit, drifted snow will give you a thrill. Finally, for those of you who have been itching to put wildlife in your paintings, this is the perfect opportunity. A small animal such as this squirrel is the best place to start. It will challenge you but not leave you frustrated. Enjoy the process!

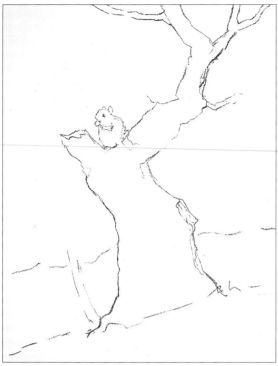

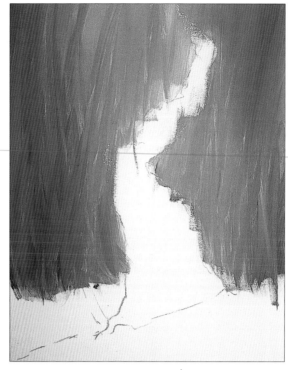

1 Create a Rough Sketch

A quick sketch is all that is necessary to get this painting started. Do not make a detailed sketch of the squirrel yet; you will do it in a later step. Use your no. 2 soft vine charcoal.

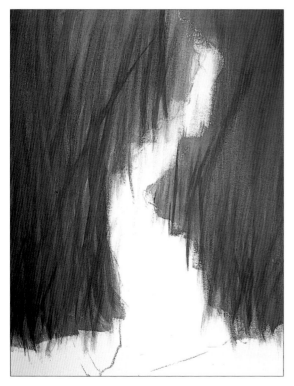

2 Underpaint Background

There is no sky in this painting; it is an all ground-level background. The background should be blurred, giving the effect of a shallow depth of field in a photograph, with only the foreground in focus. First, using your hake brush, lightly wet the background on each side of the tree and apply a liberal coat of gesso. Then, using long vertical strokes, begin adding tones of purple, Burnt Sienna, Burnt Umber, Hooker's Green, orange and blue. Create a soft, mottled background that suggests tall grass and weeds. Angle your brush in different directions to create various thicknesses of weeds. The overall tone should be on the purplish side.

3 Add Darker Weeds to Background

Be sure the background is completely dry. Using your no. 6 bristle brush, begin adding a few darker weeds of different colors, just slightly darker than the background.

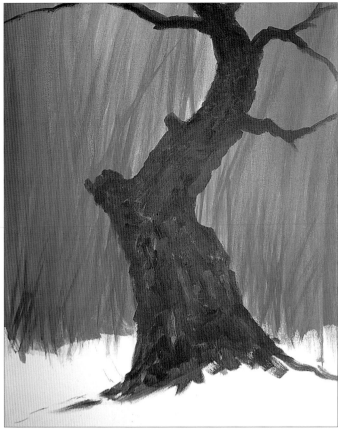

4 Underpaint Tree Trunk

This is a fun, quick and easy step. Using your no. 6 or no. 10 bristle brush, mix together most of the colors on your palette, especially the darker colors. Simply block in the basic shape of the main trunk with choppy vertical strokes. Do not overblend the colors, and add touches of white to help with minor value changes. Remember to keep the edges somewhat soft—no harsh edges.

5 Underpaint Snow

Mix white with touches of purple, blue and a tiny bit of Burnt Sienna to gray the mixture. Using a no. 10 or no. 6 bristle brush, block in the snow behind and in front of the tree. Drift the snow up against the tree and among the weeds, using a light, feathery drybrush stroke. This is an important step in preparing for the overpainting of the snow and final highlights. As you move forward, make the underpainting slightly darker to create a sense of shallow depth in the painting.

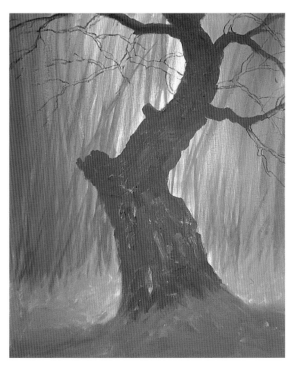

6 Sketch in Tree Limbs

Using your no. 2 soft vine charcoal, sketch in the larger tree limbs, paying close attention to the negative space.

7 Block In Intermediate Tree Limbs

Now make a mixture of Burnt Sienna, blue and a touch of purple, and add enough water to make it creamy. Then use your no. 4 flat sable brush to block in all of the intermediate tree limbs. Do not hesitate to sketch them in with your soft vine charcoal first. It is important to have good negative space and overlap. Many artists think too many or too few limbs create an undesirable effect. This is usually not the case. It is all in the proper or improper use of negative space and overlapping. So have fun, and be careful. Good eye flow is what you are after. The smaller limbs will be added later to finish this process.

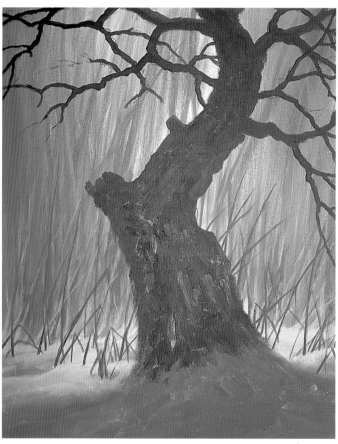

8 Highlight Snow

Begin highlighting the snow behind the tree and among the background weeds with white and very tiny touches of orange and purple. Add enough water to make it creamy. With your no. 6 bristle brush, begin drybrushing the highlights among the weeds, leaving pockets of negative space. Do not overhighlight; you will add final highlights later. It is all right to have an occasional buildup of snow in terms of thickness. The main thing is not to make it solid.

9 Add Close-up Weeds in Background

Add a few individual close-up weeds with your no. 4 flat sable brush and/or your no. 4 round sable brush. Make a creamy mixture of Burnt Sienna, purple and a touch of white. These weeds should be slightly darker than the background. They can vary in color from a rust or mauve to brownish. Remember that you will highlight them and add more color later. Use the chiseled side of your flat sable brush to make the wider weeds. Experiment with different amounts of pressure to create thick and thin weeds.

10 Highlight Snow and Weeds in Background

Mix white with a touch of orange—only enough to slightly tint the white. Make the mixture creamy and use your no. 4 round sable brush. Gently drybrush the highlight upward, starting at the base of each weed on the left side. The highlight should gradually disappear. Sometimes I use my finger to soften or blend the snow. This is not the final highlight, so again, do not get it too bright at this stage. This step really helps settle down the weeds and gives the painting a nice glow.

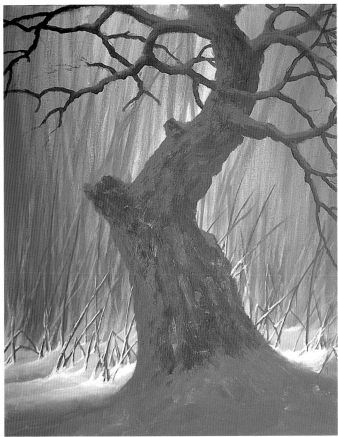

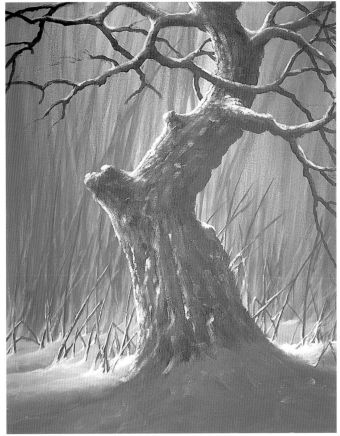

11 Underpaint Snow on Tree

It is important to remember that when you paint snow, it is best to have a bluish, purplish or grayish underpainting. Mix blue, white and a touch of purple. Using your no. 6 bristle brush, smudge a small amount of this color on the snowy parts of the tree, with a heavier concentration on the left side and on the top of each main limb. Remember not to overpaint this color, or you will lose the contrast with the dark background that gives the tree its depth.

12 Highlight Snow on Tree

This is a rather simple but important step, because the highlights set the stage for the brightness of the entire painting. You want to achieve the effect of snow that has stuck to the bark of the tree. First, mix white with a tiny touch of yellow. Using the no. 4 flat sable brush, carefully drybrush the highlight on top of the bluish purple underpainting, but don't completely cover it. You should be able to see all three colors: the dark tree, the bluish purple underpainting and snow highlight. Your tree should have good depth at this stage.

13 Paint Smaller Tree Limbs and Block In Knothole

Your main goal in this step is to complete all of the tree limbs using your no. 4 script liner brush. First, mix a very fluid mixture of Burnt Sienna, blue and a touch of purple. Add just a touch of white to soften the color. Start on an existing limb and pull your brush outward, gradually decreasing the pressure until you have a nice, tapered smaller limb. Be sure to overlap your limbs, creating nice pockets of negative space. Next, mix blue, Burnt Sienna and a touch of purple to block in your knothole using your no. 4 flat sable brush. With the same brush, drybrush a soft highlight color of white slightly tinted with yellow around the edge of the knot-hole to give it a recessed appearance.

14 Highlight Foreground Snow

This step really brings the painting to life. Mix white with a touch of yellow. Using a no. 6 bristle brush or a no. 4 flat sable, begin drybrushing the snow highlights. You can create a variety of contours for the snow just by turning your brush in different directions. The key is to leave plenty of pockets of negative space. Notice the careful placement of the snow highlights so that the shadows automatically appear. This is simply the result of not overpainting your subjects.

15 Add Foreground Weeds

Mix Burnt Sienna with purple and thin it with water until it has an inky consistency. Use your no. 4 script liner brush to begin painting in the weeds. Hint—place the weeds in depressions in the snow and in the shadow areas. This will make the weeds look like they are settled down into the snow. Also, notice that the weeds are a little stiff because they are cold and brittle.

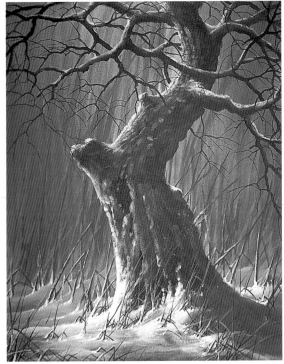

16 **Highlight Weeds and Drifted Snow**
This is a simple process. First, highlight the weeds with a creamy mixture of yellow and orange. This will add a rich, warm feeling to the painting and is a good complement to the blues and grays. Use your script liner brush for this step, and carefully highlight the left side of the main weeds. Mix white with a touch of yellow—just enough to tint the white. Using a no. 4 round sable brush, drift the snow up against the base on the left side of each weed. This effect "plants" the weed and gives the painting a glow.

17 **Sketch Squirrel and Highlight Tree Limbs**
Highlight the tree limbs the same way as in step 16, using the mixture of yellow and orange—but also add a touch of white. Brighten the snow on the limbs if needed. Next, use the soft vine charcoal to make a rough, accurate sketch of the squirrel. Use any squirrel reference photo you wish; the painting technique will remain the same. Always sketch the animals slightly smaller than you want them because they have a tendency to "grow" as you paint them.

18 **Block In Squirrel, Add Highlights and Shadows**
This process involves three simple steps. First, use Burnt Umber and a no. 4 flat sable brush to block in the squirrel. Be sure the canvas is completely covered, and that you do not have a hard line. Next, mix white with blue and purple for the reflected highlight. Use a no. 4 flat sable brush to drybrush this highlight on the shadow side of the tree and larger limbs. This is a very common procedure for creating roundness. Last, add a tiny bit of Burnt Sienna to the mixture to gray the color, and use your no. 4 round sable brush to paint in the shadows cast by the larger weeds. Just follow the contour of the ground with a drybrush stroke.

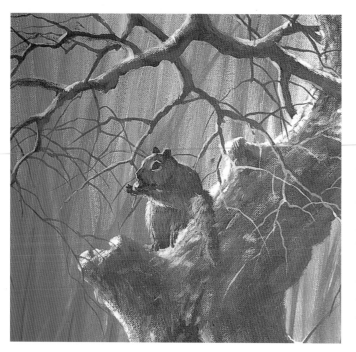

19 Highlight Squirrel

Highlighting birds and animals requires a very delicate touch, especially with a small animal like this squirrel. You will need your no. 4 flat sable and your no. 4 round sable brush. Mix white with Burnt Sienna to create a light rust color. Then lightly load your flat sable brush and barely skim the surface of the canvas, following the contour of the squirrel's body. The color will dry darker, but that is the effect you want. It is best to build the highlight in stages instead of all at once. Now do the same for the outer sunlit edge of the squirrel, except use your no. 4 round sable brush and a mixture of white and yellow. You will want to do some experimenting with both brushes and different consistencies of paint. Each of us handles this kind of detail work very differently. The secret, however, is the consistency of the paint and the pressure applied to the brush.

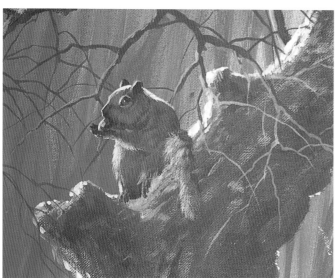

20 Add Final Highlights to Squirrel

This step is identical to step 19. The only difference is that you are making the highlight brighter and the details sharper. The technique is the same, of course. It may take one or two more layers of highlights to get the squirrel as bright as you wish. Fill in the details of the squirrel's eye.

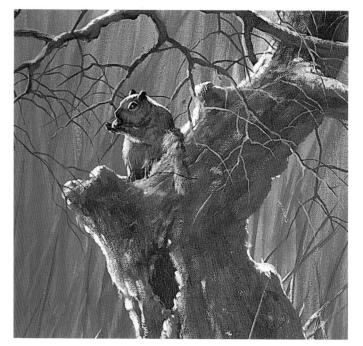

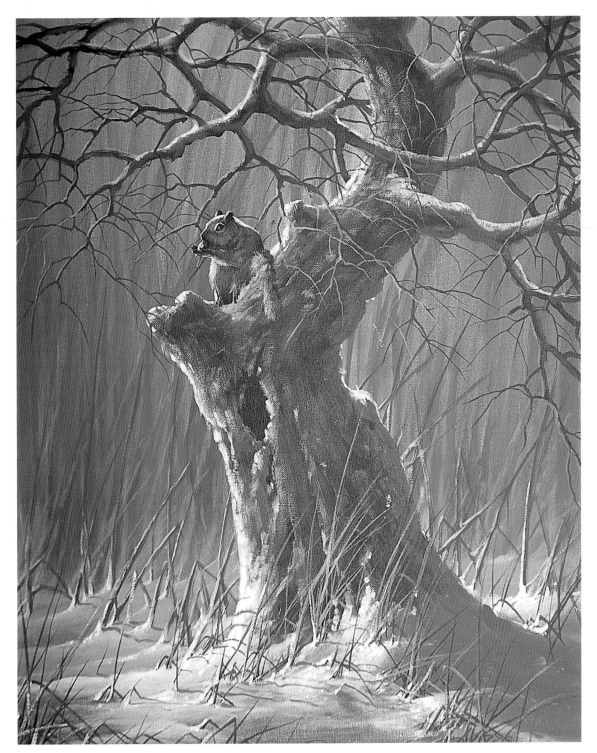

21 Add Final Details, Highlights, Glaze and Snow

This step is optional. If you are happy with your painting, you should stop. However, it is fun to glaze the painting and add the falling snow. To apply a glaze, mix a very thin mixture of water and a little white. It should look like milky water. It is best to lay the painting on a flat surface when applying this glaze. Use your hake brush and paint a thin wash over the entire painting. When it dries, you can add falling snow with a stiff toothbrush and a mixture of water and white. Spatter little dots of snow within your painting, and for larger snowflakes use your no. 4 round sable brush with a little pure white. Dab straight onto the canvas in various places. Add just enough to create the effect of close-up snowflakes. I hope you learned a lot from this painting experience!

Mountain High
16" × 20" (40.6cm × 50.8cm)

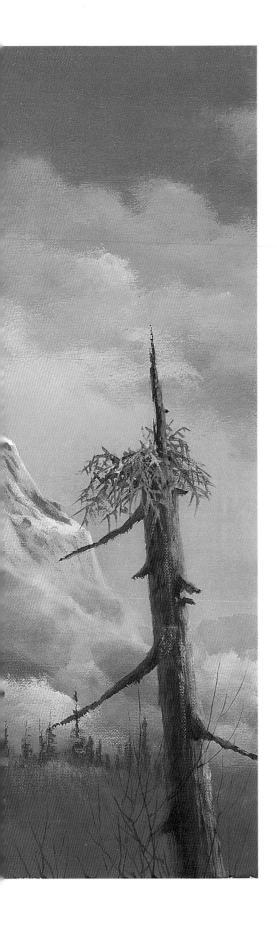

Mountain High

Because I lived in the mountains for many years, I am drawn back there repeatedly. I have fond memories of the many different atmospheric conditions and ever-changing colors. This painting is set near Angelfire, New Mexico, a place that I dearly love and had the pleasure to live in for many years. This is a study of the mountain itself and its powerful, towering presence. The many steps involved in completing the mountain are a lesson in using negative space within the mountain to create its form—an exercise that can cause the most seasoned artist to take several deep breaths. I have simplified the steps and the basic mountain structures to help you better understand this painting. This is a very fun painting, and with a little perseverance you will have great success.

1 Basic Sketch

All paintings require a very basic, simple sketch. The sketch is important to help fix in your mind all the basic components of a painting: composition, design and perspective. Use your no. 2 soft vine charcoal.

2 Underpaint Base of Sky

Use your hake brush to lightly wet the sky area, then apply a liberal coat of gesso. While the gesso is still wet, begin at the base of the sky on each side of the mountain sketch and apply a touch of yellow and red. Blend upwards using large X-strokes until the color gradually disappears.

3 Underpaint Top of Sky

First you want to create a nice, soft bluish gray. Mix white with blue, a touch of Burnt Sienna and a very small touch of purple. With your hake brush, apply the color at the top of the sky and blend downward until you meet the orange color. Then switch to your no. 10 bristle brush and scumble the gray color into the orange color. This step begins the process of creating clouds. Add touches of gesso as you soften and blend the two colors together. It is OK if the sky is a little rough, as long as the blended edges are soft. Remember, this is only the underpainting.

4 Add Lighter Clouds

In this step, you will begin refining the sky. As is the case with most paintings, your sky sets the stage for the rest of the painting. You will need either your no. 6 or no. 10 bristle brush, or both. Add white to the mixture from step 3 or mix a light gray of white, blue and a touch of Burnt Sienna. Scumble the first layer of lighter clouds. Create only their basic forms, and do not make them too bright. You will brighten them in the next step.

5 Highlight Clouds

In this step, you will highlight to create more dramatic cloud forms. Mix white with a touch of orange. Gray this color by adding a very tiny touch of blue. This color should still be warm and bright enough to create a good contrast and help establish three-dimensional form. Your no. 6 bristle brush is best suited for this. Load a small amount on the edge of the brush and begin drybrushing the outer edge of your cloud formations. Carefully blend into the main body of the cloud. Keep your edges soft. You will add final highlights later.

6 Block In Distant Mountains

This is a very simple and quick step, yet one of utmost importance. This is the only area where you will establish depth in the painting. Mix white with a touch of blue, purple and a small dab of Burnt Sienna. The color should be on the purplish side and slightly darker than your background. Using your no. 6 bristle brush, drybrush in the basic shape of your distant mountains. Darken the mixture as you come forward until you have three layers of values.

7 Underpaint Mountain

This step is loose, free, and fun and will help you work out your frustrations. First, use your no. 10 bristle brush to mix several colors in a mottled fashion so they will not turn to mud or blend into one color. I usually mix straight on the canvas. Begin with gesso, then add touches of blue, purple, Burnt Sienna and red or Alizarin Crimson. You want the mountain to have an overall purplish gray tone with various shades. Enjoy the process of putting on the colors loose and free. The paint may be rough with brushstrokes showing—just be sure the canvas is completely covered.

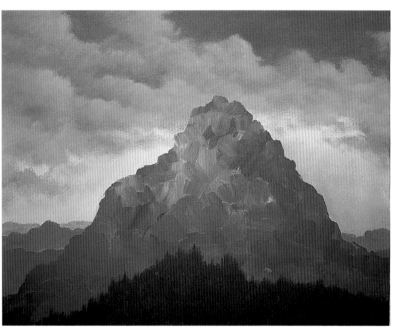

8 Underpaint Foreground Mountain

In this step you will create the tree-covered mountain in the foreground using a no. 6 bristle brush and a mixture of green, purple and white. This should create a greenish gray with a slight purple tint. Load your brush with a thick amount. Turn your brush vertical to the canvas, and use short, choppy strokes to suggest the tips of the pine trees. Remember this is only the underpainting. Highlights and details will be added later. You only need to give your mountain a good basic shape.

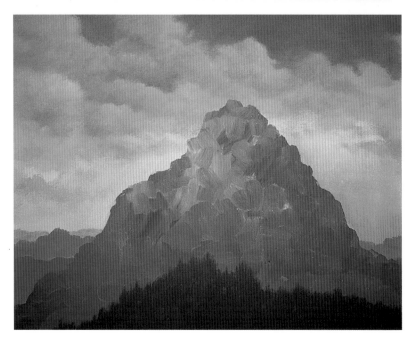

9 Detail Mountain, Phase I

Now to begin the exciting task of creating the form details of the mountain. Use your no. 6 bristle brush or your no. 4 flat sable, whichever you prefer. There are several phases to reaching the desired outcome. Be patient— it will be well worth the time. Mix white with a touch of orange and a very small touch of purple to gray the mixture, which should be thin enough to allow the background to come through. You are not ready for any bright highlights in this phase; you only want to find the basic forms. Drybrush the highlights throughout the mountain, creating various pockets of well-balanced negative space. Do not worry if you cover too much of the background. You can always come back with darker values to correct it later.

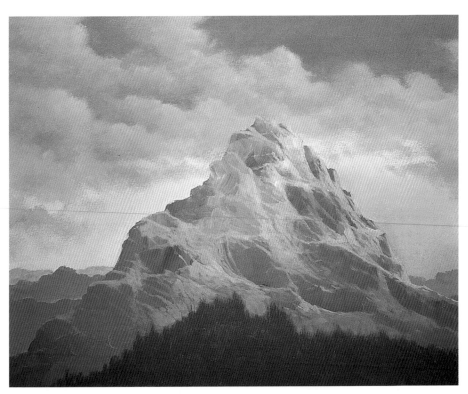

10 Detail Mountain, Phase II
Continue with the same color as in step 9; just add a little more white or orange to slightly brighten the value. Use your no. 4 flat sable brush and begin brightening the sunlit parts of the mountain. In this phase, you need to be careful with the location and formation of these highlights. This is a drybrush stroke, but you still need just enough water to make the paint move easily. This step may take awhile because you may rework some areas two or three times.

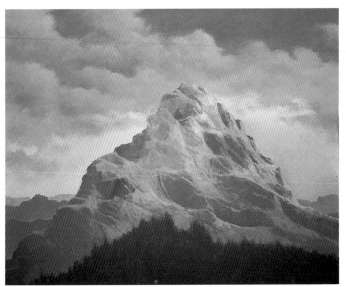

11 Detail Mountain, Phase III
In this phase, you will go back to some of the darker values to begin correcting or changing some of the forms. You will also add some of the darker values. It may not seem like much has changed in this step from the last one, but notice that the darker areas are more defined, refined and, in some cases, darker. Use your no. 4 flat sable brush and mix white, purple, blue and touches of Burnt Sienna to create this darker value. Adjust your forms until you are satisfied. You must be sure you are pleased with your overall mountain before moving to the final phase.

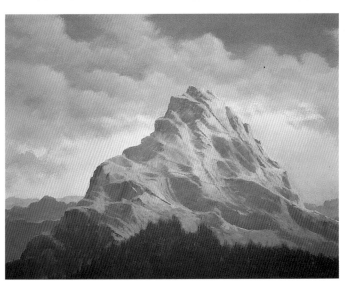

12 Detail Mountain, Phase IV
The mountain begins to take on a little more character with the addition of some snow, low-hanging clouds, and more shadows and highlights. There is not a whole lot of instructional advice I can give you here, except to continue to arrange and rearrange the physical makeup of the face of the mountain. You can achieve this by working the light and dark areas into the areas of negative space. The shadow of the snow is a mixture of white, blue and purple; the light part of the snow is pure white with a touch of yellow. Apply snow to the upper part of the mountain. I usually use a dabbing technique to put on the light snow after I have put on the shadows. Do not be afraid to experiment.

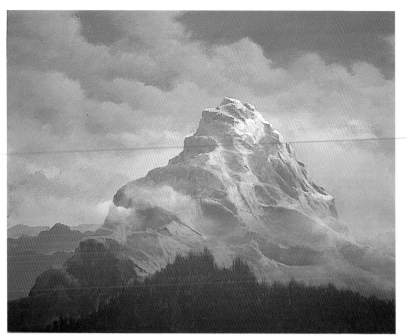

13 Add Final Highlights

Brighten the low clouds and snow, and you should have everything well in place. The final highlights are mostly pure white to accent the snow. Putting the highlights on thick will give your painting texture, and it will appear more like snow. In addition, add brighter highlights on the sunlit side of the mountain. Use your no. 4 flat sable brush to paint the final highlights with a mixture of white and orange.

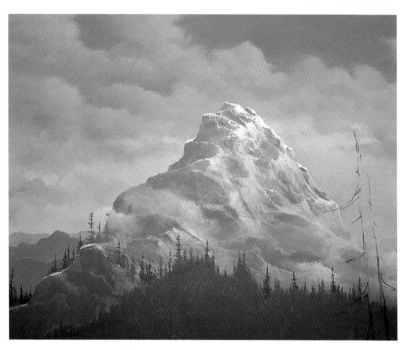

14 Add Pine Trees and Sketch Large Dead Tree

Mix green, purple and white. Use your no. 4 flat sable brush to dab in the small pine trees at the tree line on the large mountain, then extend the top of the trees up from the tree-covered mountain. Notice this is the end of the tree line, so the trees are scattered. It is especially important to use good negative space so your eye will flow nicely across the center of the painting.

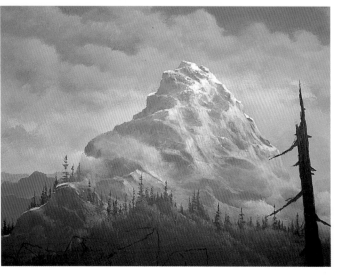

15 Highlight Pine Trees and Block In Dead Tree

In this step, use a no. 6 bristle brush and mix white with green and a touch of Thalo Yellow-Green. Now, using a drybrush stroke, gently dab the highlights onto the edges of the trees. Using a downward drybrush stroke, begin at the base of the trees and create a layering effect to suggest the tops of trees, brush or other vegetation. Notice that I left some of the background coming through between the layers to give the top of the mountain depth. Block in the large dead tree with a mixture of Burnt Sienna, purple and blue, then sketch in the rocks with your soft vine charcoal.

16 Block In Rocks and Add Mist

Block in the rocks with Burnt Sienna, blue and purple using your no. 6 bristle brush. Use rough, choppy strokes because there is no need to be too careful at this stage. Mix white with a touch of blue and purple. Drybrush this purplish blue color on with your no. 6 bristle brush. Use a haphazard scumbling motion, starting at the bottom and working your way up until the color has blended into and around the background.

17 Highlight Rocks and Dead Tree

In this step, you will need a no. 6 bristle brush and no. 4 flat sable brush. Mix white with a touch of orange and a little dab of purple. Use short, choppy strokes in different directions, and cover the top of each rock. As the color dries it will darken, so you will need to repeat this process of layering until you get the desired effect. The background should show in places to help create form and depth. Add a bit more orange to the highlight color. Turn your no. 4 flat sable brush vertically and use short, choppy strokes to create the bark on the tree. Repeat this step as needed. Now mix white, blue and purple for the reflected highlight and use the same technique to apply a little bit of this color to the dark side of the tree—but not too much.

18 Highlight Clouds

This step is not absolutely necessary. However, you can make your clouds a little brighter by applying a little white with a touch of yellow or orange. Add one or two layers of this highlight to the top right side of the clouds. Use your no. 6 bristle brush with a drybrush scumble stroke. This is a good time to drag a few clouds across the mountaintop to add interest to your painting.

19 Block In Eagle

This is a very simple step. First, sketch the eagle with a soft lead pencil (no. 4b or no. 6b works the best). Then mix Burnt Sienna and blue with a touch of white and use your no. 4 round sable brush to block in the bird. Next, add blue, purple, and white to part of the mixture for the head and tail. You will use the rest of the dark mixture in the next step. Use a touch of yellow and orange for the beak and talons.

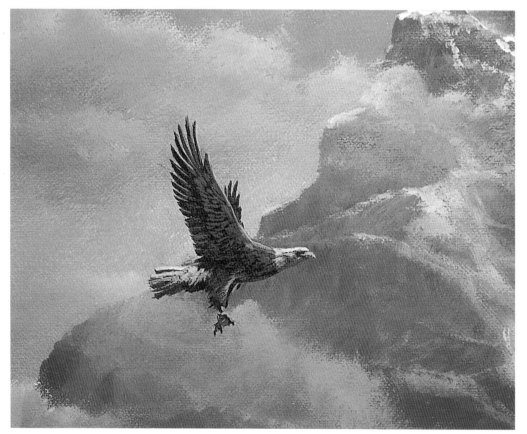

20 Detail Eagle

Add white to the original dark mixture of the bird to change the value. Using the no. 4 round sable brush, make quick single strokes on the wings to suggest feathers. Do the same for the body, following its contours using the appropriate stroke length for each section of the body. Since this is such a small bird, fine details are not necessary. You want to create only the suggestion of detail. Now highlight the head and tail with pure white, again using quick single strokes. Touch up the beak and talons with pure yellow and you are done. Be cautious not to overwork the feathers.

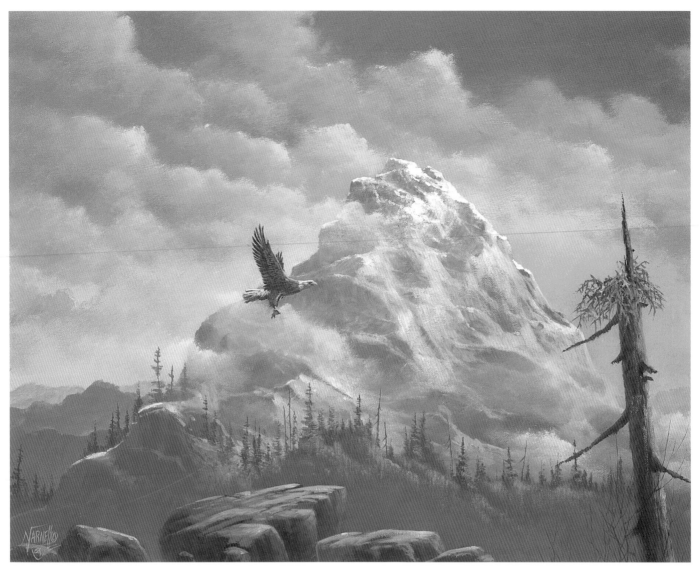

21 Add Final Details

As usual, this is where you finish the painting to satisfy your desires. For instance, I added the nest with my no. 4 script liner brush and a mixture of a brownish gray. I added a few highlights here and there and cleaned up a few rough edges. Frankly, even though this is a very easy step, it is also the most difficult because most artists do not know when to stop. Remember the three P's: Don't piddle, play or putter.

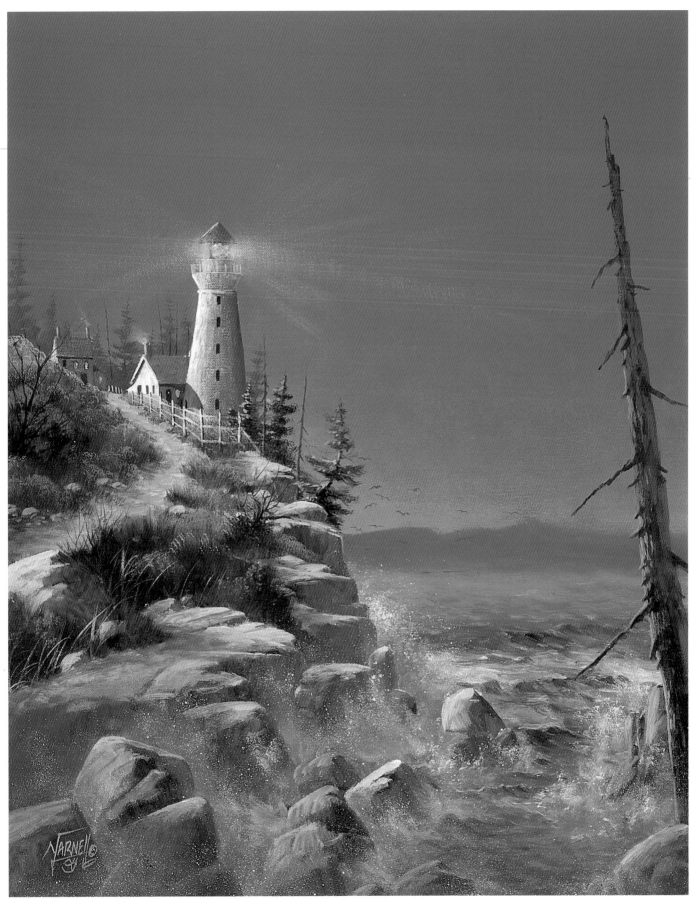

Above the Waves
16" x 20" (40.6cm x 50.8cm)

Above the Waves

In my many travels across the country to research and study different subjects, none has intrigued me more than the lonely lighthouse sitting high on its rocky perch. A lighthouse is a great subject for studying rock formations, ocean waves and dramatic skies and other atmospheric conditions. As you will see, the greatest challenge in this painting is arranging the rugged, rocky cliff formation so it blends gracefully into the crashing waves. Do not be intimidated by all of the rocks; they are easier than you think. Have fun and enjoy the process.

1 Create Sketch

Use your soft vine charcoal to make a quick, rough sketch of the main components of the composition. Remember that you can always refer to your pencil sketch for more accurate reference.

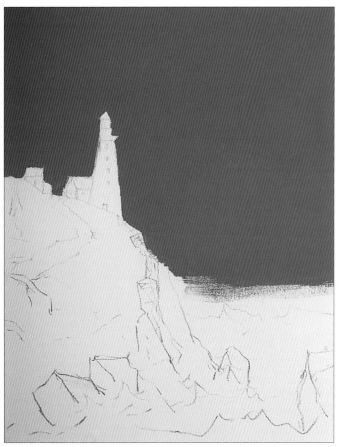

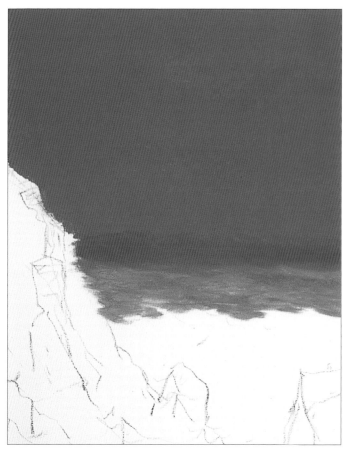

2 Block In the Sky

You will want a very soft, hazy, grayish blue sky to set the mood for the painting. First, premix a large pile of paint on your palette. Mix four parts gesso to one part of Ultramarine Blue, and add a touch each of Burnt Sienna and purple. Add just enough water to make it nice and creamy. Lightly wet your canvas with water and apply a liberal coat of the grayish mixture using large X-strokes to create a soft, blended sky. You will drybrush the horizon color later.

3 Block In Distant Hills

There should be a dramatic sense of depth in this painting. Add a touch more Burnt Sienna and purple to a small amount of the sky color. Use a no. 6 bristle brush to scrub in the suggestion of distant hills, carefully softening the color into the sky. Add white to the sky color and use long, horizontal strokes to establish the beginning of the water below the hills. Come forward about 1½" (4cm).

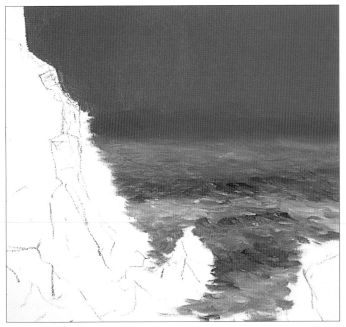

4 Underpaint Middleground Water

This is a fun step. Paint the water in the middle-ground with your base sky color and your no. 6 bristle brush. Use short, choppy, horizontal strokes. Add touches of green, purple and blue in different amounts and in different orders to create color and value changes. The darkest part of the water should be toward the middle. Be sure the canvas is well covered and do not overblend. You should be able to see the movement of the brushstrokes on your canvas.

5 Drybrush Horizon

Here you will add a soft light to the horizon with your no. 6 bristle brush. Mix white with very tiny touches of orange and red. The color should be a very pale salmon color. Then, with a very dry brush, use heavy pressure to scrub in the color with a scumbling stroke. Scrub until the edges blend into the sky and the distant hills have been softened.

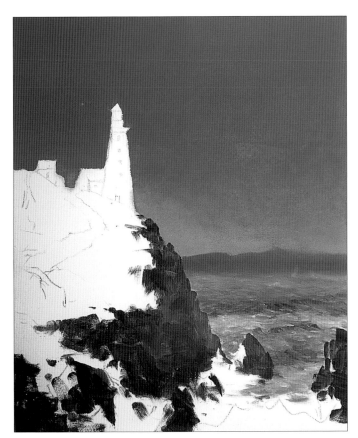

6 Underpaint Cliff and Rocks

This is an important step. Again using a no. 6 bristle brush, mix blue, Burnt Sienna, purple and touches of white in various amounts and different combinations. Use a variety of unorganized strokes to simply block in the main body of the cliff and rocks. Be sure to put the paint on thick enough to cover the canvas. Brushstrokes should be visible and not overblended.

7 Underpaint Waves

Use your no. 6 bristle brush to mix gesso and touches of your sky color. Apply loose strokes using different edges of the brush. Block in the crashing waves behind and around the foreground rocks. Be sure to soften your edges. Use good negative space to create action and interest in the waves.

8 Underpaint Cedar Trees

Once again using your no. 6 bristle brush, mix white with a touch of green and purple. This should create a purplish gray color. Scrub in the basic shape of the cedars, keeping the edges soft. Be sure they have unique, interesting shapes with good negative space. If you have trouble using the no. 6 bristle brush, substitute a no. 4 flat sable brush. It may help to make your paint mixture a little creamier than usual.

9 Block In Lighthouse

Resketch the lighthouse using soft vine charcoal. Then mix a brownish gray from Burnt Sienna and a touch of blue and white. Using a no. 4 flat sable brush, carefully underpaint the entire lighthouse. Be sure the canvas is well covered.

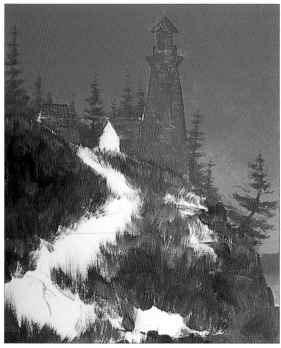

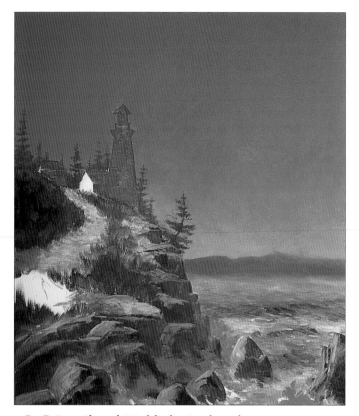

10 Underpaint Top of Cliff and Cedars

Here you want to create a soft, loose effect which we will later turn into grasses and rocks. Use a no. 10 or no. 6 bristle brush and a combination of white, green, purple and Burnt Sienna. Scumble color on this area using vertical strokes to the top of the cliff. Then use your no. 4 flat sable brush to mix green and purple with a touch of white and block in the cedar tree hanging over the cliff.

11 Detail and Highlight Rocks, Phase I

This step will challenge your artistic abilities. First, locate and form the basic shape of the rocks with white and a touch of orange and yellow. Add a touch of water, but do not make the consistency too thin. Use a no. 4 flat sable brush to apply a small amount of paint. This step is time-consuming, so be patient. You may have to work and rework the rocks until you get the shapes you are after. Remember, this is the first phase. You will make adjustments in shape, size, value and color in phase II. Be careful and watch the negative space around the rocks so they will have good balance.

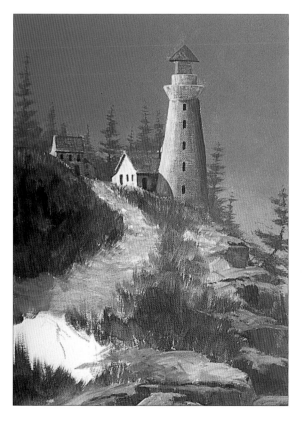

12 Lighthouse Details

As with the rocks in the previous step, you will begin to create the form of the lighthouse with subtle highlights. A no. 4 flat sable and no. 4 round brush will give you more control of your brushstrokes. Mix white with a touch of yellow or orange and begin highlighting the left side of the lighthouse and buildings. Use a grayish mixture of blue, Burnt Sienna, white and a touch of purple for the shadowed side. Blend carefully, but do not worry about details in this step. This is a good time to adjust the shape, composition and perspective of your buildings.

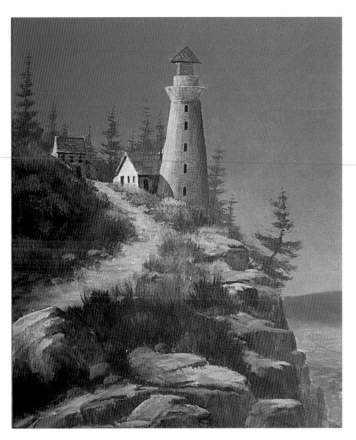

13 Add Details on Top of Cliff

Now you will add the grasses, bushes and miscellaneous rocks on the top side of the cliff. Use a no. 10 bristle brush and a mixture of green, white, purple and a touch of Burnt Sienna. Drybrush various arrangements of grasses and clumps of bushes. Keep in mind that the pathway needs to wind around the edge of the cliff and back to the lighthouse, and that as you come forward, the grass and bushes should become darker. Do not hesitate to switch to a smaller brush if needed, either a no. 6 bristle or a no. 4 flat sable.

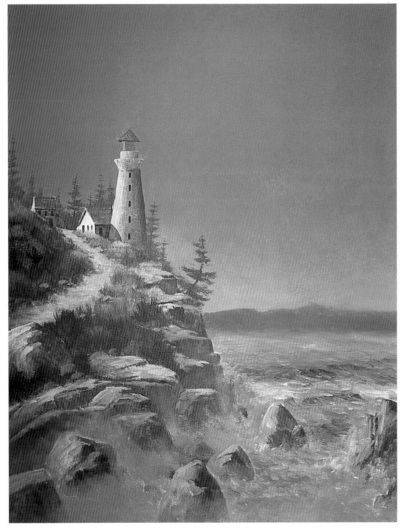

14 Apply Mist to Base of Rocks

Soften the foreground with mist from the crashing waves by simply mixing white with a touch of purple and blue. Use your no. 6 bristle brush and apply pressure to scrub in the mist. Begin at the bottom and work up, around and in between the rocks until the mist fades out.

15 Create Miscellaneous Details

At this point, begin applying intermediate and final details throughout the painting. For instance, block in the large dead tree with Burnt Sienna, blue and a touch of purple using a no. 4 flat sable brush. Scrub in a bluish white haze at the back of the painting with a no. 6 bristle brush, and add a few assorted trees behind the lighthouse using Hooker's Green and purple. Do not be afraid to add other details that you like. Remember, you have the artistic license to do as you please, as long as you follow the basic rules of color, value and composition.

16 Detail and Highlight Cliff and Rocks, Phase II

This step will continue to challenge you. Using a no. 4 flat sable brush and a no. 4 round sable brush, mix a sunshine color of white with a touch of yellow and orange. Continue shaping your rock formations by drybrushing on the highlights using different strokes and different angles of the brush. Remember, the paint will dry darker than when you first put it on, so you may need to go over your area two or three times until it has the brightness you want. You may need to use the dark value to help shape or reshape a rock or to add cracks and crevices. A semidry brush is best for this process.

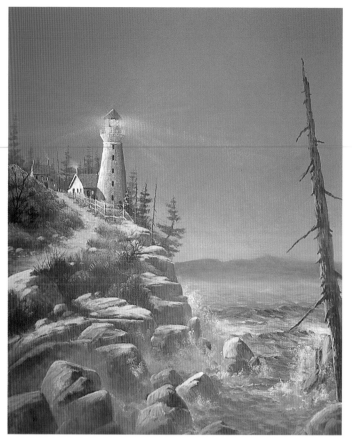

17 **Add Details and Glow From Lighthouse**
Using a no. 6 bristle brush, mix white with just a touch of yellow. Repeat the same technique that you used with the mist. Use heavy pressure and drybrush the glow around and over the top of the lighthouse. Drybrush sunlight rays like a sunburst using the same brush and paint mixture. Then use your no. 4 flat sable brush to begin detailing the lighthouse with white and yellow, and use a grayish purple for the shadows. For the highlights around the bushes, use a mixture of yellow, white and green. Dab highlights on the bushes around the lighthouse using a no. 6 bristle brush. Do not be timid at this stage; be aggressive with your highlights.

18 **Create Highlights and Details**
As you can see, there are now more highlights and details, especially around the lighthouse. Be as creative as you comfortably feel while remembering the three P's: Don't piddle, play or putter. Use good judgment when adding details such as flowers; too much color will overpower your painting. At this stage, I recommend standing back a few feet and studying the painting for a few minutes. Then go back and add or take away highlights and details. You can finish the waves by adding darker values to create forms that are more suitable. As with the rocks, do not hesitate to reshape your waves until you are satisfied.

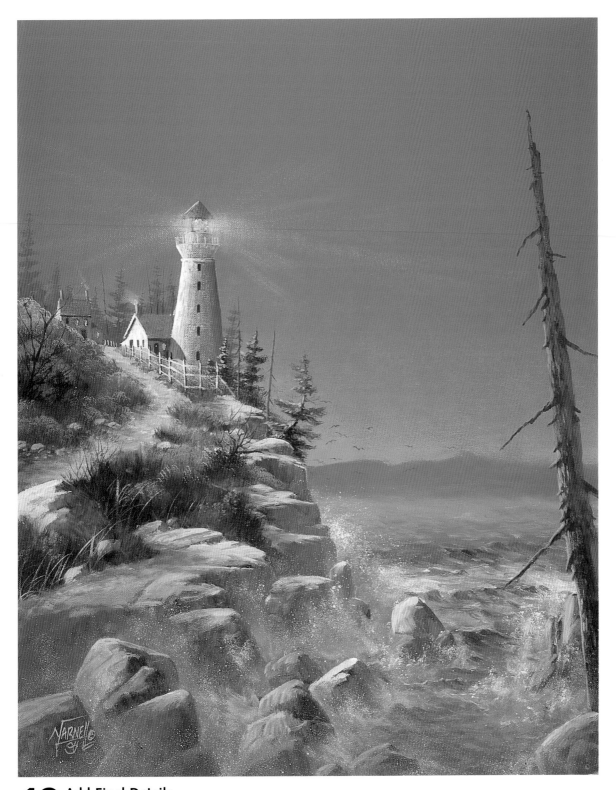

19 Add Final Details

This is an exciting step. As the waves crash against the rocks, they not only create a mist, but also drops of water. This effect is best achieved by using a toothbrush. First, mix a thin mixture of white and water. Swish a toothbrush around in the paint mixture. On a scrap of paper, practice making spattered drops of water by running your index finger across the bristles of the toothbrush. When you are confident, apply spatters around the rocks where the waves are crashing. Experiment with different distances from the canvas to create different effects. Finally, add the details such as birds and weeds, and your painting is complete.

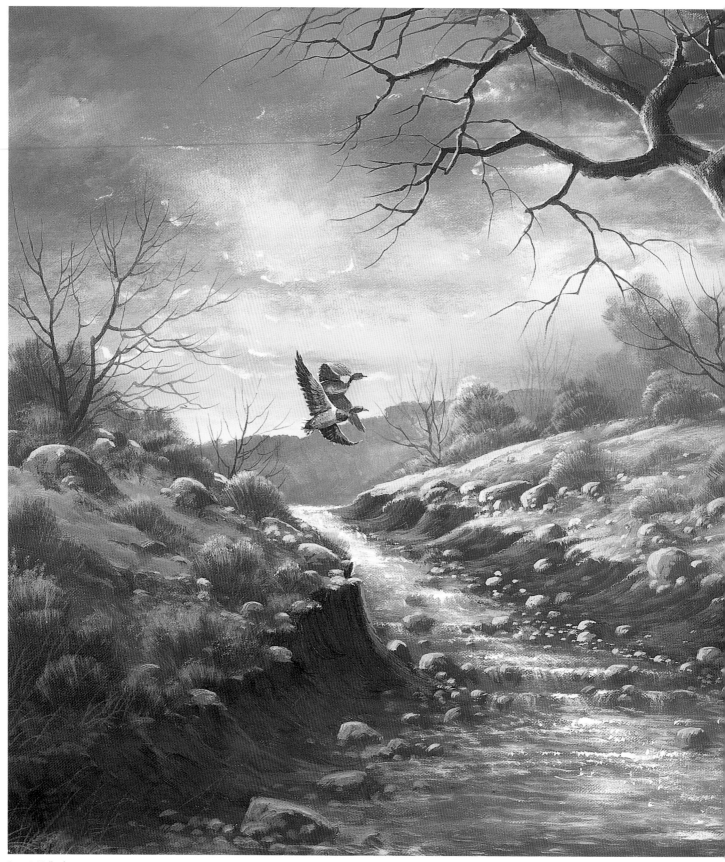

Sunset Mallards
20" x 16" (50.8cm x 40.6cm)

Sunset Mallards

You may have to wear sunglasses when you do this painting. It can be a little outrageous to paint with this much pure color. I have always enjoyed painting with much softer, muted tones, and I was often accused of not having enough courage to branch out with more color in my work. Lo and behold, I finally worked up the courage to experiment with brighter, more intense color. To my surprise, it has absolutely transformed my career. Using more color has created more interest in my work, increased my sales, made me a more well-rounded artist, and has given me so much more to offer as a professional instructor. The main purpose for this painting is to help you overcome the fear of using pure color and to give you more experience in the use of negative space. With this many rocks and bushes, you really must have a good understanding of composition in order to create proper eye flow. Good luck and enjoy your experience.

1 Make a Rough Sketch

Use your soft vine charcoal to draw a rough sketch of the basic contour of the land. Although this is a busy painting, there is no need to do a lot of sketching.

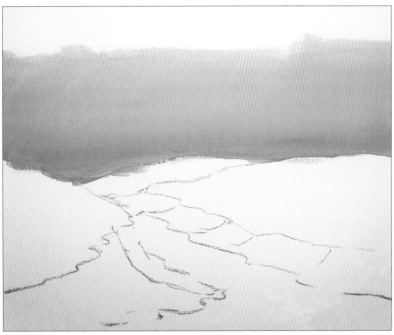

2 Underpaint Base of Sky

Since this is a bright sky with several color changes, it will take several steps. First, apply a thin layer of gesso and pure orange with your hake brush. Now use your hake brush to make large X-strokes, blending upward until you go about halfway into the sky area. Be sure the upper edge is soft, not harsh. This makes blending the other colors much easier. Another important thing to remember is to be sure the canvas area you covered with gesso and pure orange is covered completely.

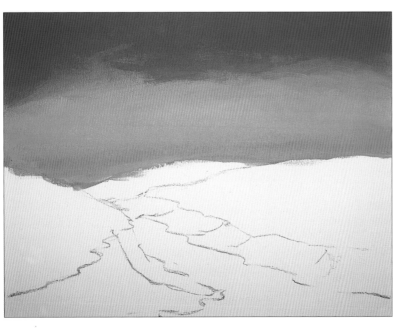

3 Underpaint Top of Sky

Apply a heavy coat of gesso and Ultramarine Blue to the top of the sky area with your hake brush and blend downward until you meet the orange. Notice that in the area where the blue and orange meet, the edges are very rough and unblended. This is acceptable because it sets the stage for the different cloud formations to be added later. The next few steps will cover the rough edges.

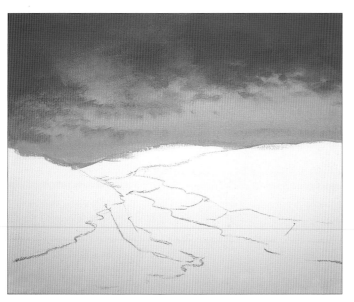

4 Add Miscellaneous Clouds

In this step, drybrush in the first series of darker clouds. Switch to a no. 10 bristle brush and mix blue, purple, white and a touch of Burnt Sienna. You will need to experiment with this mixture until you are pleased with the color; the mixture should be creamy. Load your brush with a small amount of paint and begin at the center of the painting. You will use a very dry brush and a scumbling stroke. It is important to scrub on the clouds so the edges blend into the painting underneath. In addition, start paying attention to the composition of the cloud formations, specifically to the negative space around them.

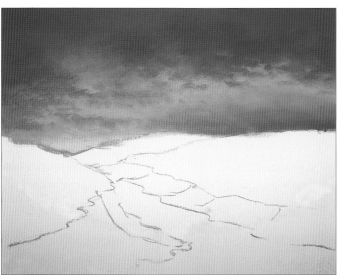

5 Add Yellow and Red Glow

This is a simple step, but you must be careful to soften the brighter colors into the background so that there are no hard edges. Use your no. 6 bristle brush to scrub pure yellow into the dip on the left-hand side of the horizon. Then with pure red and a touch of orange, begin on the right side of the horizon and scrub in this bright color until it fades into the background.

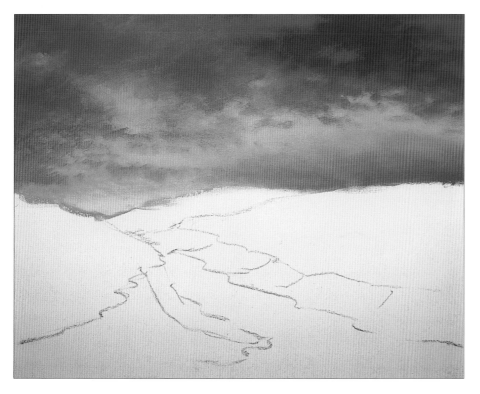

6 Drybrush Darker and Lighter Clouds

This is an important step because these clouds will be the final formations. Notice the darker clouds in the upper right-hand corner. These clouds will be our focus. Mix blue, purple and a touch of Burnt Sienna; also add a touch of white to soften the mixture. Use a no. 6 or no. 10 bristle brush to scrub in these darker clouds until you are satisfied with the composition.

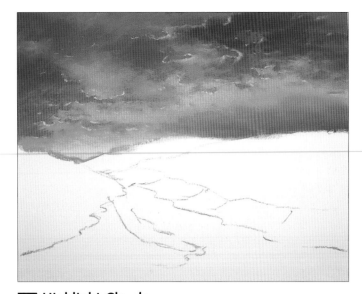

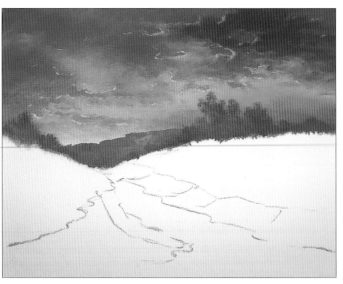

7 Highlight Clouds

This step is like putting a silver lining on a cloud. Slightly tint white with a touch of yellow and orange. Use a no. 4 flat sable brush to carefully apply the highlight color to the outer edges of the clouds. You want to apply choppy, broken highlights to accent the edges of the clouds and give them form. Notice that not every cloud is highlighted, just particular ones so that the sky has good balance.

8 Block In Distant Hills and Trees

Mix white with blue, purple and a touch of Burnt Sienna. The mixture should have a purplish tone. Use your no. 6 bristle brush to scrub in the distant hill. This is a simple formation, so don't get carried away. Darken the mixture slightly by adding more blue, purple and Burnt Sienna. In fact, you can add a touch of Hooker's Green if your wish. Use a no. 6 or no. 10 bristle brush to dab the mixture straight onto the canvas. Form the basic shape of the trees, keeping the negative space rule in mind. Also, note that this value is only slightly darker than the distant hills.

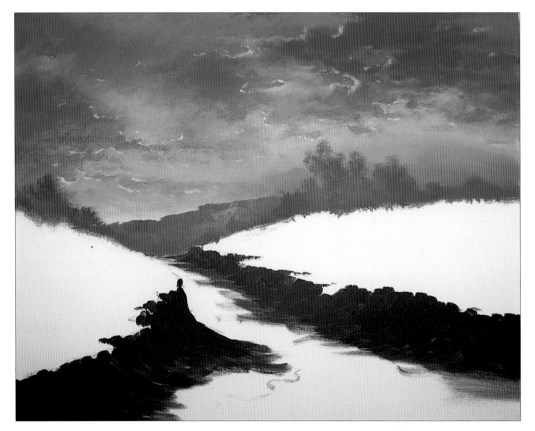

9 Underpaint Banks

This is a very simple step. Use a no. 6 bristle brush with a combination of Burnt Sienna, Burnt Umber and a touch of purple to underpaint the banks on each side of the stream. Use a comma stroke and follow the contour of the bank. The edges can be rough and loose, as long as the canvas is covered well.

10 Underpaint Tops of Banks

In this step, you will underpaint the top of the banks. Make a mixture of white, Burnt Sienna and a touch of purple and blue. Use a no. 10 bristle brush to scatter these colors around on top of the banks. The white will be your blending medium. Notice that it is not an even color, but mottled. This is all that is necessary at this stage.

11 Underpaint Stream Bed

Underpaint the stream bed with a no. 6 bristle brush to create a mottled effect as you did on the top of the banks. The mixture should have a bluish gray tint. Mix white with touches of blue, purple and Burnt Sienna. Apply using short, choppy, horizontal strokes. As you come to the back of the stream, use a mixture of white with yellow to create the reflected glow of the sun. Be sure all of your edges blend together. It does not have to be a smooth blend; just do not leave any hard edges.

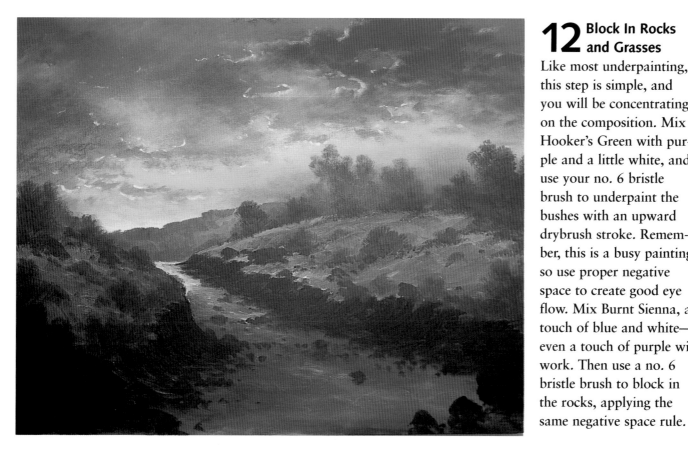

12 Block In Rocks and Grasses

Like most underpainting, this step is simple, and you will be concentrating on the composition. Mix Hooker's Green with purple and a little white, and use your no. 6 bristle brush to underpaint the bushes with an upward drybrush stroke. Remember, this is a busy painting, so use proper negative space to create good eye flow. Mix Burnt Sienna, a touch of blue and white—even a touch of purple will work. Then use a no. 6 bristle brush to block in the rocks, applying the same negative space rule.

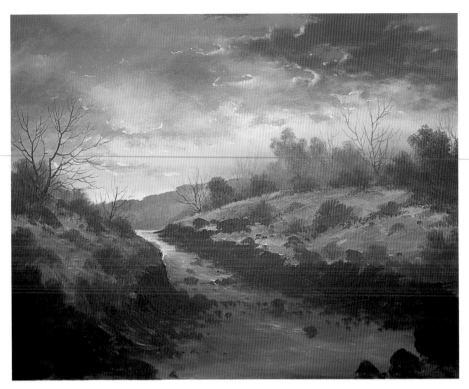

13 Paint Dead Trees

You should be very familiar with this step by now. Mix Burnt Sienna, blue and a touch of purple. Thin the mixture to an inky consistency. Use a no. 4 script liner brush to paint in all of the smaller dead trees. When adding the distant background trees, you may need to add a dab of white to the mixture to make sure the value is consistent with that area of the painting.

14 Highlight Rocks and Banks

Here begins the process of bringing the painting to life. Your sunshine color is a mixture of white with a touch of orange and Burnt Sienna. Add a touch of blue or purple to gray the mixture. With a no. 6 bristle brush, begin highlighting the rocks and banks with a drybrush stroke. Use a one-stroke technique for highlighting: Apply the highlight using one quick stroke and maybe one or two more quick strokes if necessary. It is important not to overhighlight these rocks. Quickly establish their basic form, then stop.

15 Block In Large Dead Tree

Start this step by sketching in the shape of the tree with soft vine charcoal. This will give you a good guide. You can use pure Burnt Umber and a no. 6 bristle brush or a no. 4 flat sable brush, whichever you prefer. Paint in the basic shape of the main body of the tree and a few of the most important limbs. Be sure to apply the paint thickly for solid coverage.

16 Highlight Sand and Rocks

Use a mixture of white with a touch of orange and yellow. I prefer to use a no. 4 flat sable brush because it gives me more control over my strokes. Follow the contour of the land around the rocks and bushes when applying this color. Make sure the coverage is thick enough so that it stays opaque and bright. Use a drybrush stroke and feather the edges into the background sand. Now brighten this color if you need to and select the rocks that need to be brighter. Carefully highlight them. The foreground rocks will not need too much more light.

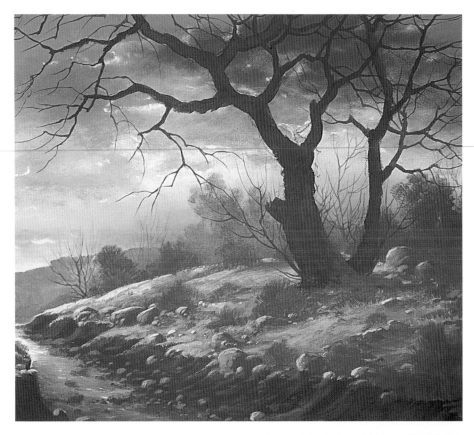

17 Add Limbs to Large Tree

This step can be time-consuming. You will use your no. 4 script liner brush and an inky mixture of Burnt Umber and water to finish the tree limbs. Again, be aware of the negative space.

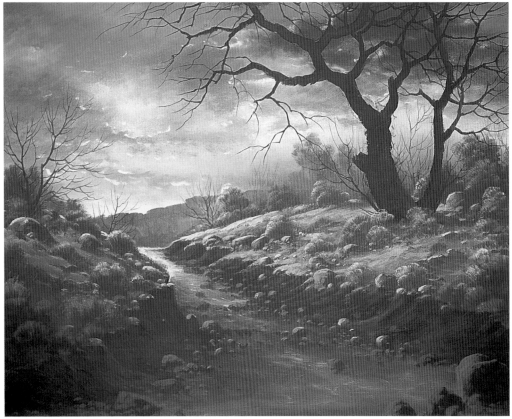

18 Highlight Bushes

You can use several colors to highlight your bushes. Your highlight colors can be a mixture of Hooker's Green with white and yellow, or Hooker's Green with white and orange, or Thalo Yellow-Green and orange. Be your own judge, but be sure it is compatible with your color scheme. I prefer to use a no. 6 bristle brush; however, a no. 10 bristle brush will also work. Simply dab on the highlight to give each bush three-dimensional form.

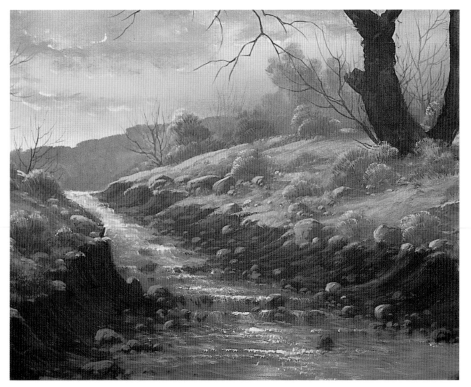

19 Detail and Highlight Water

This step will add a great deal of interest to the painting. Mix white with a touch of yellow and begin at the back of the stream. Use a no. 6 bristle brush or a no. 4 flat sable and apply short, choppy strokes. Move forward and add highlights and ripples to the water. As with every other phase of the painting, be sure to use good negative space as you place the highlights and ripples. The background should show through in several places; this allows the stream to have contrast. Use a drybrush stroke that is pulled forward, skimming the top of the canvas to give movement to the water. The water is calmer at the front of the stream, and you should use more of a horizontal stroke there.

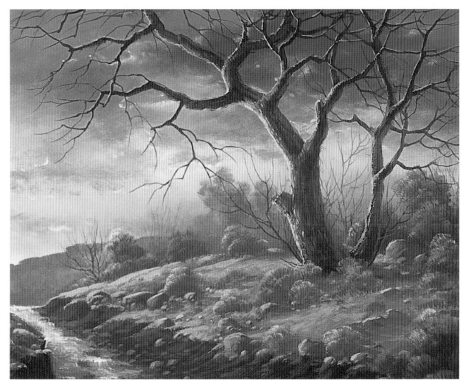

20 Highlight Dead Tree

Because of the very intense light of the painting, the left side of the tree should have a very bright highlight. The right side of the tree will have a soft purplish reflected highlight. First, mix white with a touch of orange and yellow. Use a no. 4 flat sable brush to apply the color using short, choppy, vertical strokes to create a barklike effect. Gradually fade this across the tree. Then add the reflected highlight to the dark side of the tree using the same technique. The reflective highlight is a mixture of blue, white and purple. You do not need to highlight every small limb, just a few to give the tree a sunlit effect.

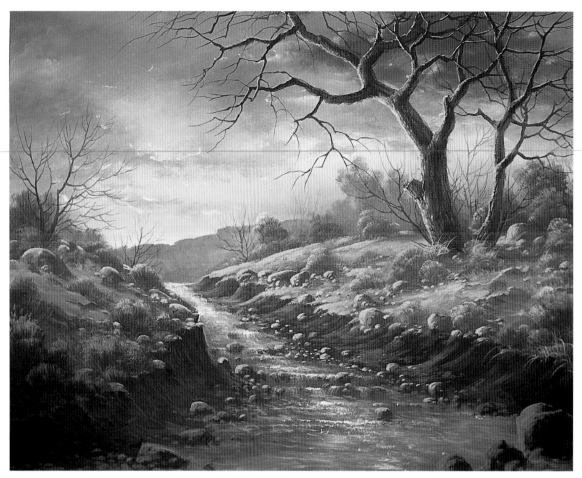

21 Add Final Details and Highlights

Now you need to make several decisions about finishing your painting. Do you wish to add brighter highlights, some individual weeds, complementary accent colors, or soften the edges? If you are completely satisfied at this stage, it is best that you quit. You do not want to look for things to add. It's important to find the discipline to stop.

22 Underpaint Ducks

This step is optional. If you don't want to add ducks to your painting, you may prefer to add another type of bird. If you choose to add the ducks, make a quick sketch with your soft vine charcoal or soft lead pencil. Underpaint your ducks with a brownish gray mixture of white, blue and Burnt Sienna. Use a no. 4 round sable brush to underpaint their entire bodies. Allow the underpaint to dry and erase the excess charcoal. Now you are ready to add details.

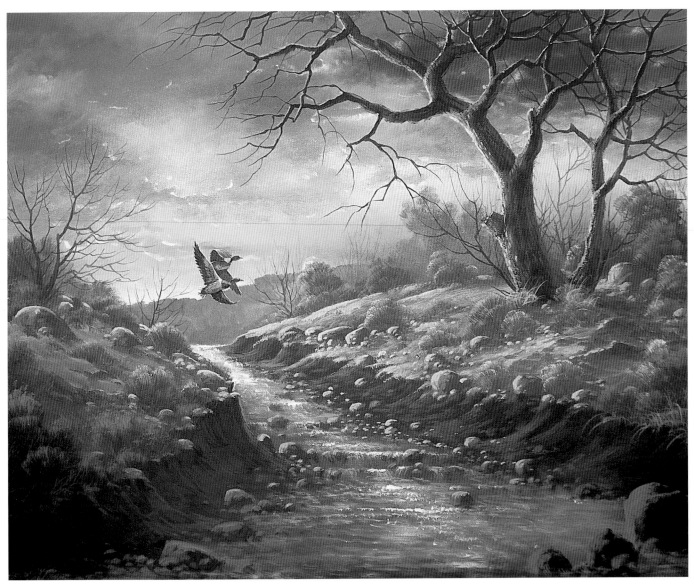

23 Finish Ducks

Continue to add the appropriate colors and highlights with your no. 4 round sable brush to form and identify the birds. Use Hooker's Green for the head with a dab of yellow-green highlight. Use Burnt Sienna for the breast with a touch of orange for the highlight. Add a dab of white to the original gray to soften and form the bodies. Use pure white as an accent highlight and a small amount of Burnt Sienna and blue for the darker values. I cannot give you explicit instructions on detailing these birds because the details are only suggested. Most importantly, do not overwork the ducks by giving them too much detail, too many highlights or an intense value. Remember, simplicity is the key to a good painting.

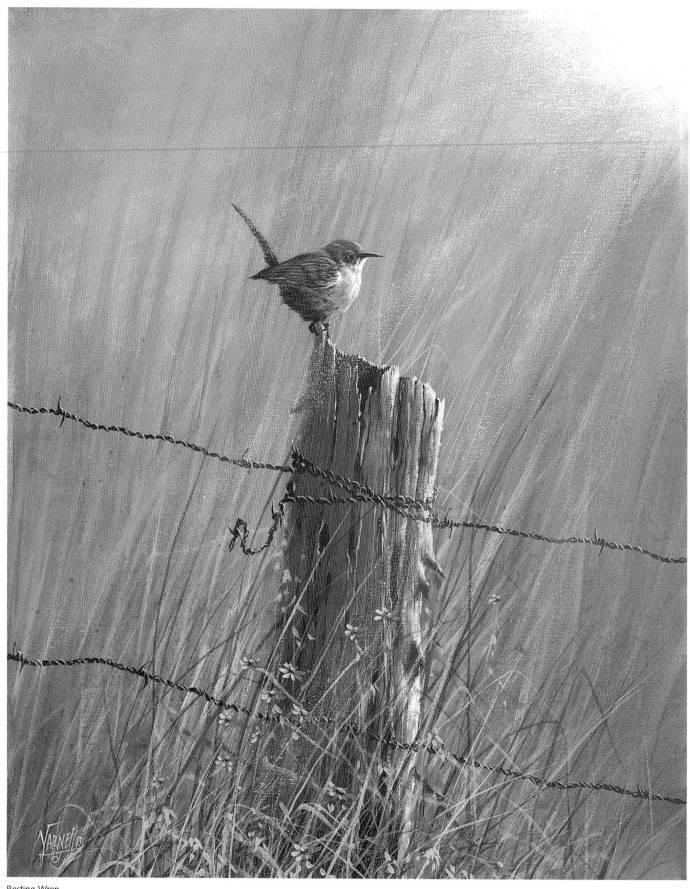

Resting Wren
20" x 16" (50.8cm x 40.6cm)

Resting Wren

The goal of this painting is to create a slightly blurred background and, as we come forward, create in-focus objects: weeds, flowers, a fence post, wire and a bird. All of these objects are somewhat detailed against a mottled background. Of course, the ultimate focus is on the bird and fence post. If you choose to, you can create an almost photographic representation of these objects, but I think an artist should leave something to the imagination. It is best not to overdetail, but rather to make a good artistic representation. This painting contains lessons in painting feathers and weathered wood. Even if you prefer painting other subjects, you will still find educational value in learning how to paint these textures. Learning how to simulate weathered wood on the fence post will truly challenge you and help you grow as an artist. This painting is a real joy.

1 Underpaint Background

This is an unusual way to begin a painting, but a painting that has a mottled background is easier when you start with a dark underpainting. It takes fewer layers to cover than a light or white background does. I used all the colors on my palette. Load your no. 10 bristle brush with gesso and scumble in a small section. While it is still wet, blend in whatever combinations of colors you wish. Move to another section and repeat this process until the canvas is completely covered.

2 Add Color to Background

Mix a creamy mixture of Hooker's Green, orange and Thalo Yellow-Green. Load your hake brush, and beginning at the bottom of the canvas, pull upwards while decreasing the pressure. As you move up, fade the color into the background. Add occasional touches of Hooker's Green, Thalo Yellow-Green and earth tones to suggest distant weeds. Do not hesitate to turn your brush on its chiseled edge and pull upward to create different weeds. Experiment with these background techniques to create some marvelous effects.

3 Sketch Fence Post

Now you need a basic sketch of the fence post. This will give you a guide for placing the background weeds. Use your no. 2 soft vine charcoal to make a very rough sketch. Notice that the post leans slightly to the right; this creates effective negative space.

4 Add Background Weeds

Add various colors and values of weeds behind the sketched-in fence post. You can use several different brushes for this step; I prefer the no. 4 flat sable and the no. 6 bristle brush. Experiment to see which works best for you. Use different combinations of colors, such as Hooker's Green, Cadmium Yellow Light, Cadmium Orange and Thalo Yellow-Green. Add a touch of Burnt Sienna here and there and thin these colors with water. Start at the bottom and pull upward, creating a variety of shapes, sizes and colors.

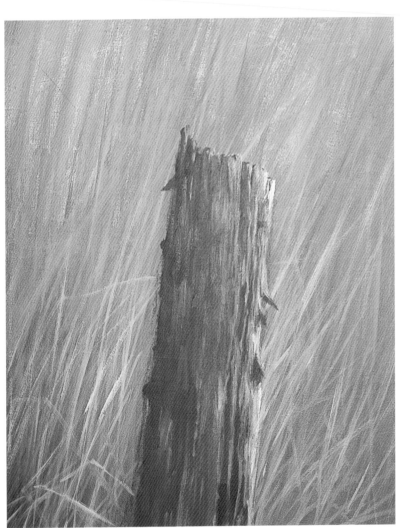

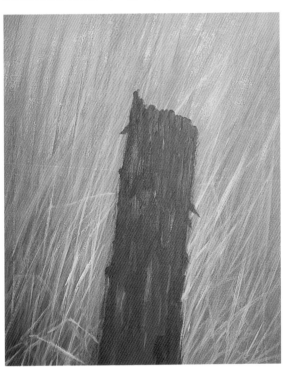

5 Underpaint Fence Post

This is an easy step. Use your no. 6 bristle brush and a mixture of Burnt Sienna, blue, purple, Burnt Umber, red and a touch of white. Use long, choppy, vertical strokes and completely cover the sketched fence post. Be careful not to overblend; keep in mind this is a round fence post. Leaving the paint rough and applying a thick coat in some areas will create the weathered look you want.

6 Highlight Fence Post, Phase I

This is the first stage of making the fence post appear round. Start on the right side of the fence post and begin blending your sunshine colors. Mix white with a touch of orange for the base color. Use your no. 4 flat sable brush and your no. 4 round sable brush to begin drybrushing the highlight with a choppy, vertical stroke. Add touches of other colors to the highlight as you go, such as red, yellow, purple or—believe it or not—Thalo Yellow-Green. Fade the highlight across and into the dark side and be sure to let some of the background show through.

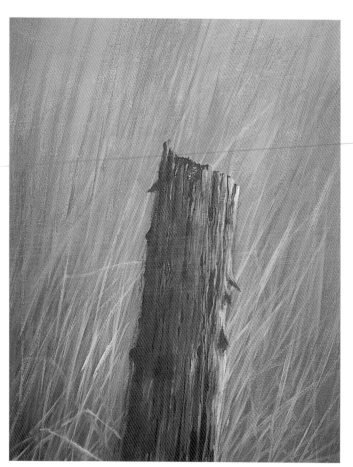

7 Add Details to Post

Here you will add some details such as cracks, holes and splintered wood. Mix blue, Burnt Sienna and purple to create a very dark mixture. Thin the mixture with water, and use your no. 4 script liner brush or no. 4 round sable brush to begin adding the dark cracks and holes. Be aware of the negative space as you add these cracks and holes. You do not want the post to become too busy. Save this color mixture for step 10.

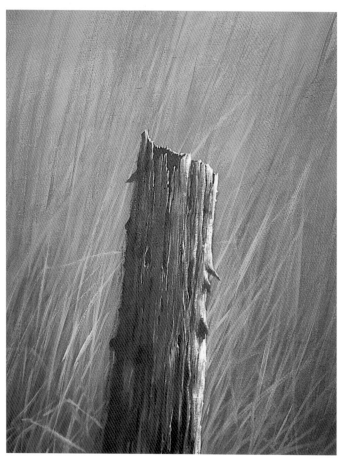

8 Highlight Fence Post, Phase II

Now you want to apply a very bright accent highlight to make the fence post really stand out and have good form. Mix white with a very small amount of yellow and orange. Use your no. 4 round sable or no. 4 script liner brush to apply the paint thickly in order to hold its brightness. Highlight only the raised areas of the wood: Use very thin slivers of thick paint to suggest a raised area. Again, be very careful not to overhighlight. You will add final highlights, if necessary, in the last step.

9 Add Reflected Highlight

This is a technique that you need to become familiar with, because it is necessary for creating roundness in an object. A reflected highlight is a mixture of white, blue and purple. I use my no. 4 flat sable brush to drybrush this color on the dark side of the fence post. Fade it across to the center of the post until it disappears. You can see this really helps the post achieve a rounded effect.

10 Add Barbed Wire

The barbed wire will add a nice touch to the details of this painting. Notice that the wire is twisted like a braid. Start with the dark mixture that you used in step 7. Thin this mixture with water and lay in the wire using a no. 4 round sable brush. Begin wherever you feel comfortable. I wrapped the wire around the top of the post and angled it straight across the bottom. Artistic license can be used to place the wire where you desire. You will highlight the wire in the next step to give it its three-dimensional form.

11 **Highlight the Barbed Wire**
Mix white with a touch of orange until it is creamy. Use your no. 4 script liner brush to highlight the top right side of each twist of the wire. This is not difficult, but it can be time-consuming. Be patient and do not make the highlights too bright.

12 **Add Foreground Weeds**
This step is very important to the overall composition of the painting. You will want to use a good variety of colors and values as well as shapes and sizes in this step. Mix these colors in any combination you desire: green, yellow, orange, Thalo Yellow-Green and touches of white. Thin with water to an inky consistency. Use your no. 4 script liner brush to begin placing the weeds around, behind and in front of the fence post.

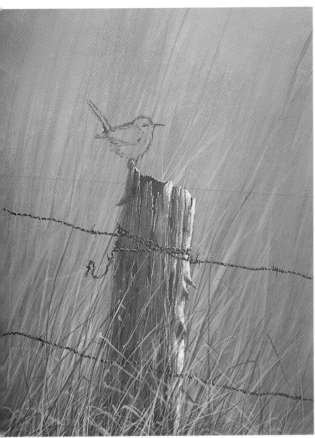

13 Sketch Wren

Make an accurate sketch of the bird with a soft lead pencil. Any time you do a close-up of birds or animals it is important to have a good, accurate sketch. The secret is to make the sketch slightly smaller than the finished bird because the bird tends to "grow" as you paint.

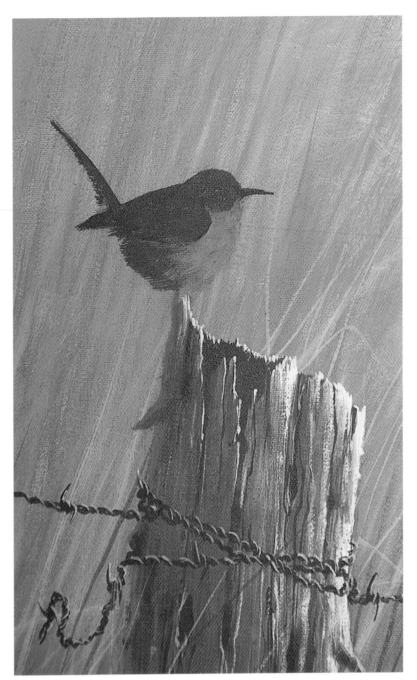

14 Underpaint Wren

There are two underpainting colors needed: Burnt Umber for the brown area of the body, and a mixture of white, Burnt Sienna and a touch of blue to create a brownish gray for the breast area. Use a no. 4 flat sable brush to underpaint the two main body parts. Keep the edges soft; adding the details later will be difficult if the edges are hard.

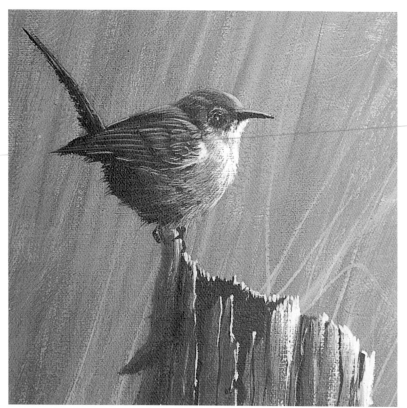

15 Detail Wren

The highlight color for the brown part of the wren is a bright rust color of Burnt Sienna, orange and white. You may want to experiment on a separate canvas before beginning this process. You can use a no. 4 flat sable or no. 4 round sable brush for detailing. Use a drybrush stroke with a small amount of paint on your brush, and follow the contour of the body. For the breast area, use white with touches of orange and yellow and use the same technique of following the contour of the body. Add touches of highlights here and there to give the bird more interest.

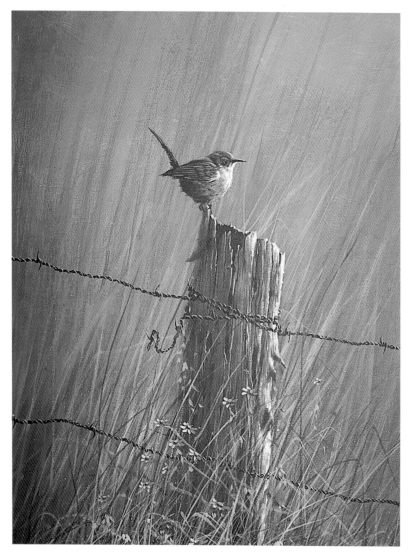

16 Add Flowers and Other Details

Finishing the painting with flowers and other highlights can be a lot of fun. Almost any color will complement this painting, so be your own judge. Add flowers and other accents with a stiff toothbrush, spattering different colors into the background. Then use a sable brush to add smudges of color within the weeds to suggest flowers that are behind the fence post. Next, paint the closer flowers and weeds, being careful not to overhighlight. Arranging the flowers so they have good composition will help balance the painting.

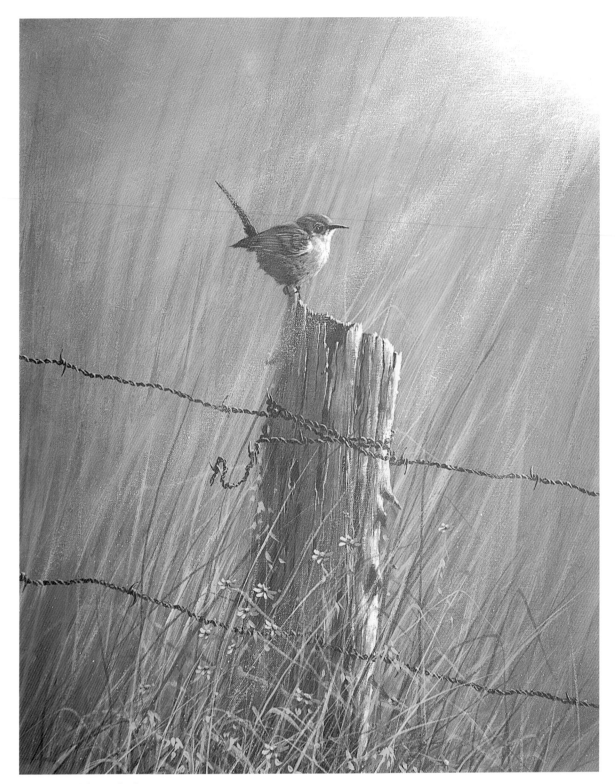

17 Add Sunlight

This step is optional. If you are pleased with your painting, there is no need to continue. However, if you are courageous, you can add sun rays. This effect adds a great touch to a painting, but overdoing the rays can be a real disaster. Here is how to proceed: Mix white with touches of yellow and orange until it looks creamy. Load a small amount on a clean, dry no. 10 bristle brush. Beginning in the corner, use a circular drybrush motion and move toward the center, decreasing pressure as you go so that the color gradually disappears. Then, from the same corner, lightly drag a very dry brush at an angle across the canvas. Repeat this step until you are satisfied with the degree of brightness.

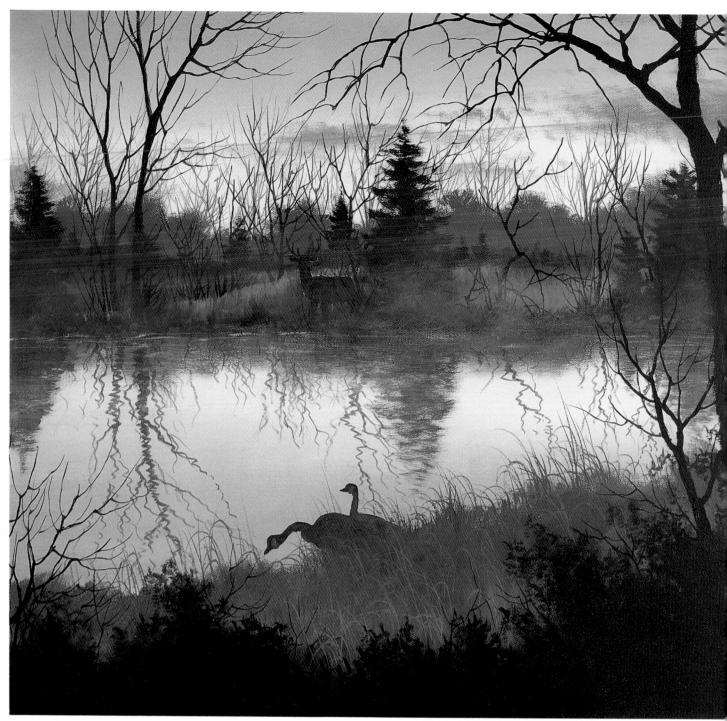

Morning Reflections
16" x 20" (40.6cm x 50.8cm)

Morning Reflections

This is a fun, exciting and challenging painting, even though the subject is very general. What makes it unique is the monochromatic effect (the use of predominately one color) and the very dramatic atmosphere. I believe it was Andrew Wyeth who said that an artist should not have to travel more than fifty miles from home to have a lifetime of subjects to paint. He was referring to the fact that if you have a good, basic understanding of composition, design, perspective, color and values, you can literally paint the same subjects repeatedly, and each painting will be unique depending on how you treat your subjects. This painting is no exception. I have done paintings of this subject dozens of times; however, as I change the atmosphere and color scheme, each takes on a character all its own. Good luck and have fun painting this early morning scene.

1 Create Charcoal Sketch

As with most paintings, begin with a very basic, rough sketch of the basic components of the painting. In this case, sketch mostly the contour of the land.

2 Underpaint Sky

On your palette, mix gesso with a touch of yellow and orange and a very tiny touch of Burnt Umber. Add enough water to create a creamy mixture. This will be your base color. Now mix gesso with a touch of yellow and orange. Use your hake brush to blend this color from the horizon line upward about halfway. While this is still wet, start at the top and blend the base color down until you meet the horizon color. Now gently blend them together using a soft feather stroke. Be sure to use large crisscross or X-strokes.

3 Underpaint Water

This step is the same as step 2. The only difference is that you reverse the location of the colors. The base color is at the bottom of the water and the lighter mixture is at the top of the water's edge. The process remains the same.

4 Underpaint Background Trees

In this step, you will create some very distant trees. This is a very early morning—and therefore backlit—setting, so the value system is not going to have the normal characteristics because of the strong contrasts. This painting will be the exception, rather than the rule. You can pull this off as long as you are careful. Make a mixture of Burnt Umber and a touch of white and even a little orange to warm the color. Use a no. 6 bristle brush with this mixture to scrub in the distant trees.

5 Underpaint Middleground, Add Clouds and Reflections

Mix Burnt Umber with a little white, and use your no. 10 bristle brush to scumble in the meadow between the water's edge and the background trees. Make sure the canvas is completely covered in this area. Then add a little white to soften the color and use a no. 6 bristle brush to drybrush in a few scattered clouds. Next, establish the reflection along the base of the shoreline with a mixture of Burnt Umber and a touch of white. Dab this color along the shoreline with a no. 6 bristle brush. Drybrush downward, scrubbing the reflection into the water, and softening all of the edges. More refined reflections will be added later. Be sure the shoreline is rough and choppy to suggest rocks and dirt.

6 Underpaint Foreground

In this step, cover the foreground completely using Burnt Umber, yellow and orange with a touch of white. With a no. 10 bristle brush, scumble all of these colors together, creating different pockets of light and dark. In addition, you want to have the suggestion of brush or bushes at the top of this ground area. Use a variety of strokes to create different effects. Experiment and have fun. You will add details later.

7 Add Background Limbs

This has always been one of my favorite steps because it really adds character to the painting. Mix Burnt Umber with a touch of white, then thin it to an inky consistency. Use your no. 4 script liner brush to add as many trees as you feel comfortable with. Remember to begin at the bottom of each tree, moving upward and out to give a proper taper to your tree limbs. Also, pay close attention to the negative space. The trees should have good form with very interesting pockets of space around them.

8 Block In Cedar Trees

I recommend in this step that you use your soft vine charcoal to make a rough sketch establishing the cedar trees. Mix Burnt Umber with just a little bit of white. This should be a very dark color, and it needs to be very creamy. Now, with your no. 6 bristle brush, begin dabbing the shapes of the cedar trees. It is OK for the paint to be thick. This thickness will add to the texture, and the tree will be easier to form. Cedar trees are short and full, not like tall pine trees.

9 Detail Middleground Meadow
Here you want to add a little sunlight to the meadow and roughen the area to look like grass. As you get closer to the shoreline, pull up some taller clumps of grass and bushes. You need a combination of Burnt Umber, yellow and orange, with occasional touches of white. Use a no. 6 or no. 10 bristle brush to begin adding pockets of light and dark areas by pulling color up here and there to create bushes. Details and highlights will be added later.

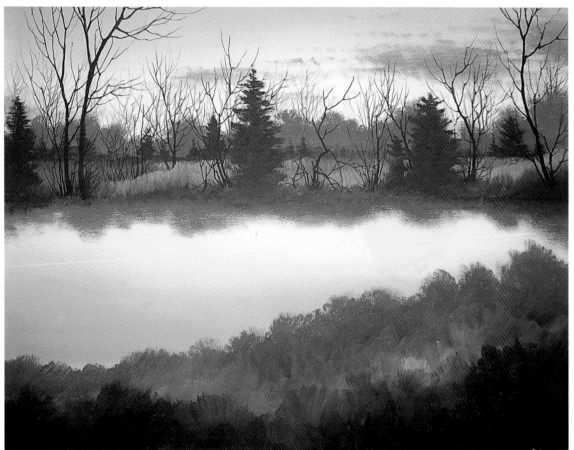

10 Block In Middleground Trees
This step is similar to step 7, except that the trees are darker and closer; in addition, they need to have more interesting shapes. First, mix Burnt Umber and plenty of water to an inky consistency. Next, using your no. 4 script liner brush, begin at the base of each tree and pull upward, gradually decreasing your pressure as the limbs taper. Go all the way across the middle of the painting with a good variety of shapes and sizes.

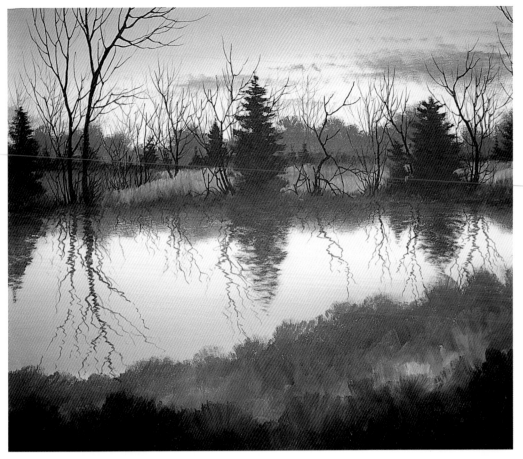

11 Refine Reflections

Now that you have completed the trees, you can paint in their reflections. These reflections are the key to this painting. Mix Burnt Umber with a touch of white until creamy. Use your no. 6 bristle brush and begin with the cedar trees. Use short, choppy, vertical dry-brush strokes to smudge in the basic shapes of the cedar trees. Keep the edges soft and allow some of the background to show through. Now switch to your no. 4 round sable brush and use the same technique for painting the dead tree reflections. You do not have to make an exact duplicate of each tree, only the suggestion. Later, you will glaze the water to soften the effect.

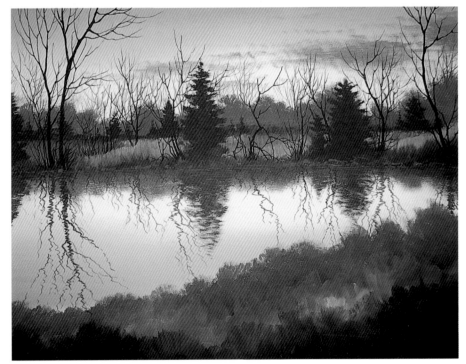

12 Detail Shoreline

This is a very simple step. Mix white and Burnt Umber to create a tan color. Use your no. 4 flat sable brush to drybrush suggestions of rocks and debris along the shoreline. Do not make it too busy or too bright; add just enough details to tie it together with the middleground and the water.

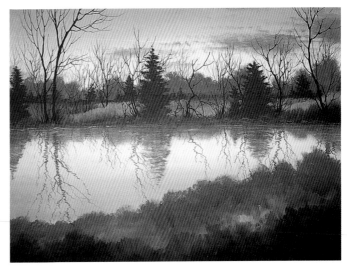

13 Glaze Water

Glazing the water is a very important step in this painting. Mix white with lots of water to create a very thin glaze. Then load your hake brush evenly. Starting at the left side of the water, lightly drag the brush across the surface of the canvas with a slight jiggle. Then move down and do another section until you have glazed the entire water area. Add a little more white to the mixture and use your no. 4 round sable brush or your no. 4 script liner brush to add a few horizontal accent highlights near the shoreline.

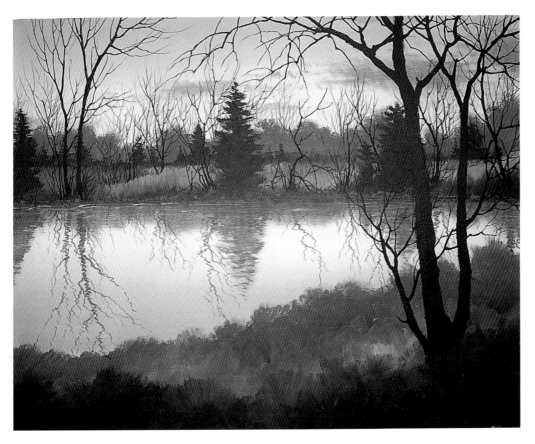

14 Block In Foreground Tree

First, make a rough charcoal sketch of the tree. Then use pure Burnt Umber and your no. 6 bristle brush to block in the main body of the tree. For the smaller branches and limbs, use the smaller sable brushes—whichever works best for you. Be sure to put the paint on thick enough to make it opaque. The best advice I can give you in this step is to be sure your tree is well balanced, with good negative space.

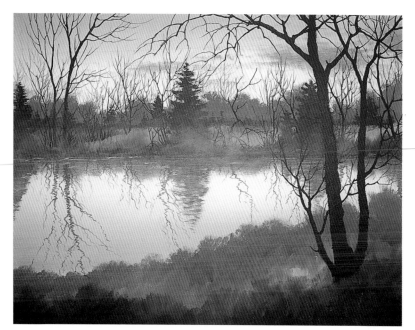

15 Mist Shoreline

Mix white with a touch of Burnt Umber to create a soft, hazy color which will also be used in the last step. Load a small amount of the mixture on your no. 6 bristle brush. Using a drybrush scumbling stroke, begin at the water's edge and work up, blending out the base of the cedar trees. This creates a soft mist or early morning fog. Be careful not to put the paint on too thick or it will become opaque and you will lose the transparent, misty look.

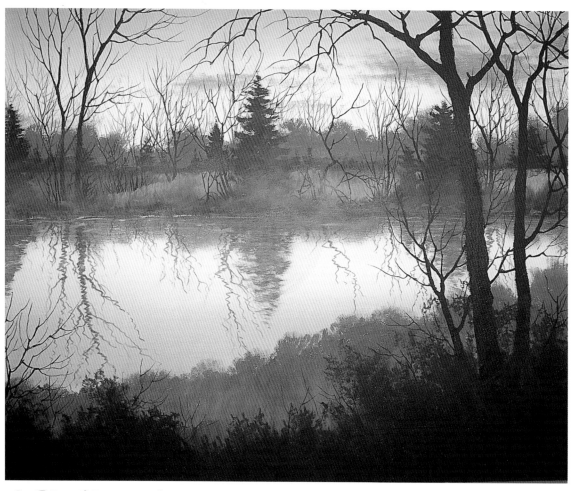

16 Detail Foreground

Now you may add final shadows, weeds and miscellaneous details. Begin by using your no. 10 bristle brush to drybrush a dark shadow around the base of the tree. Use pure Burnt Umber and pull upward, moving across the base of the painting to create brush of different heights. Then load the very tip of your paintbrush with Burnt Umber and dab at the top of the bushes to create the suggestion of leaves. Add a few small limbs with your no. 4 script liner brush and the same color.

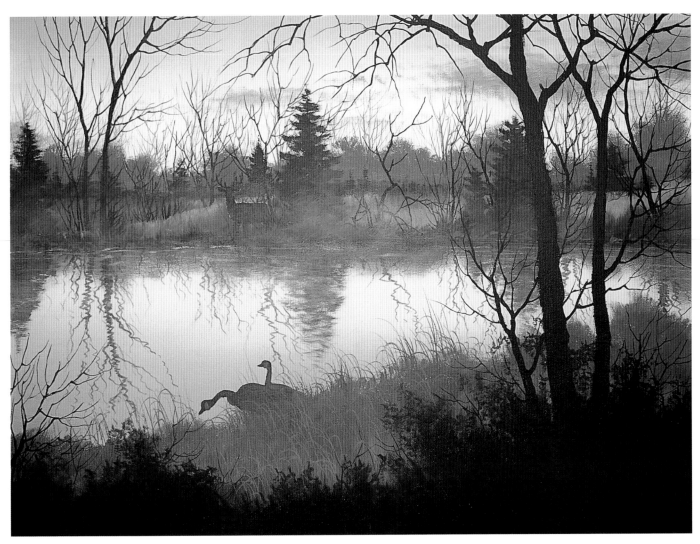

17 Add Final Details

This is a good place to use your artistic license to add any kind of bird or animal you choose, as long as it fits into the overall composition. Make an accurate sketch, then mix Burnt Umber with a little white. You will want to mix this color according to the values in your painting. Use your no. 4 flat sable brush or no. 4 round sable brush to block in the silhouette of the animals. When the paint is dry, apply a drybrush mist to soften them, as you did to the shoreline. Finally, look for things you want to add to finish your painting, such as weeds or more highlights on the water. I hope that you have enjoyed learning to create the paintings in this book. It was a pleasure painting with you.

Index

Painting has never been easier!

Jerry Yarnell makes painting fun and exciting by showing you how to transform a blank canvas into a spectacular landscape even if you've never painted before! In this book, the first in the *Paint Along with Jerry Yarnell* series, you'll find ten beautiful landscape projects, including a serene snow-covered country road, a secluded forest path, a glorious desert, a quiet lakeside church and more!

And what's more, when you paint with Jerry, you'll see how each stroke brings you that much closer to a finished painting.

1-58180-036-3, paperback, 128 pages

Discover a range of techniques for painting expressive "portraits" of your favorite homes and buildings—from cottages and barns to mansions and cityscapes.

This is some of the most comprehensive step-by-step instruction ever published by North Light Books, covering everything from perspective and composition to painting stone, brick, wood and other textures. No matter what your medium is or how long you've been painting, these "keys" will help you unlock exciting new possibilities in your art.

0-89134-977-4, paperback, 128 pages

Through 15 step-by-step watercolor demonstrations you'll learn essential techniques for mixing colors, creating textures and setting moods for an impressive range of subjects. Each exercise is packed with the details and insights you need to succeed.

Whatever your skill level, you'll become proficient at capturing the beauty and power of trees, rocks and mountains, while simultaneously refining your own painting style.

0-89134-975-8, paperback, 128 pages